DRUMMOND

Drummond

RANCH LIFE IN THE WEST

Jill Brody

TWODOT®

GUILFORD, CONNECTICUT
HELENA, MONTANA

AN IMPRINT OF THE GLOBE PEQUOT PRESS

A · TWODOT® · BOOK

TwoDot is a registered trademark of The Globe Pequot Press.

All photographs have been taken by the author.
The photograph on page 68 was previously published in *Montana Century*.

Library of Congress Cataloging-in-Publication Data
Brody, Jill.
Drummond : ranch life in the west / Jill Brody.— 1st ed.
p. cm.
"A TwoDot Book."
ISBN 0-7627-2805-1
1. Ranch life—Montana—Drummond. 2. Drummond (Mont.)—Social life and customs.
3. Ranchers—Montana—Drummond—Biography. 4. Drummond (Mont.)—Biography. I. Title.

F739.D78B76 2003
636'.01'0978688—dc21

2003047143

Manufactured in China
First Edition/First Printing

TO HERB

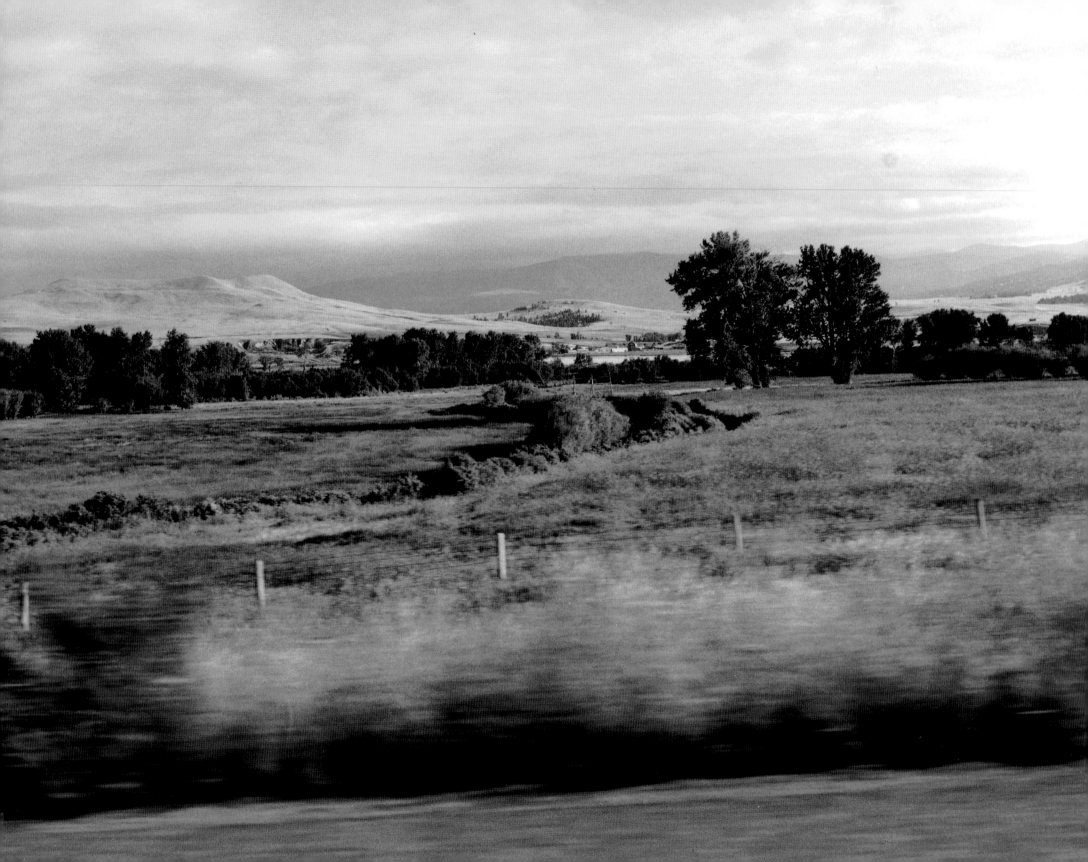

Contents

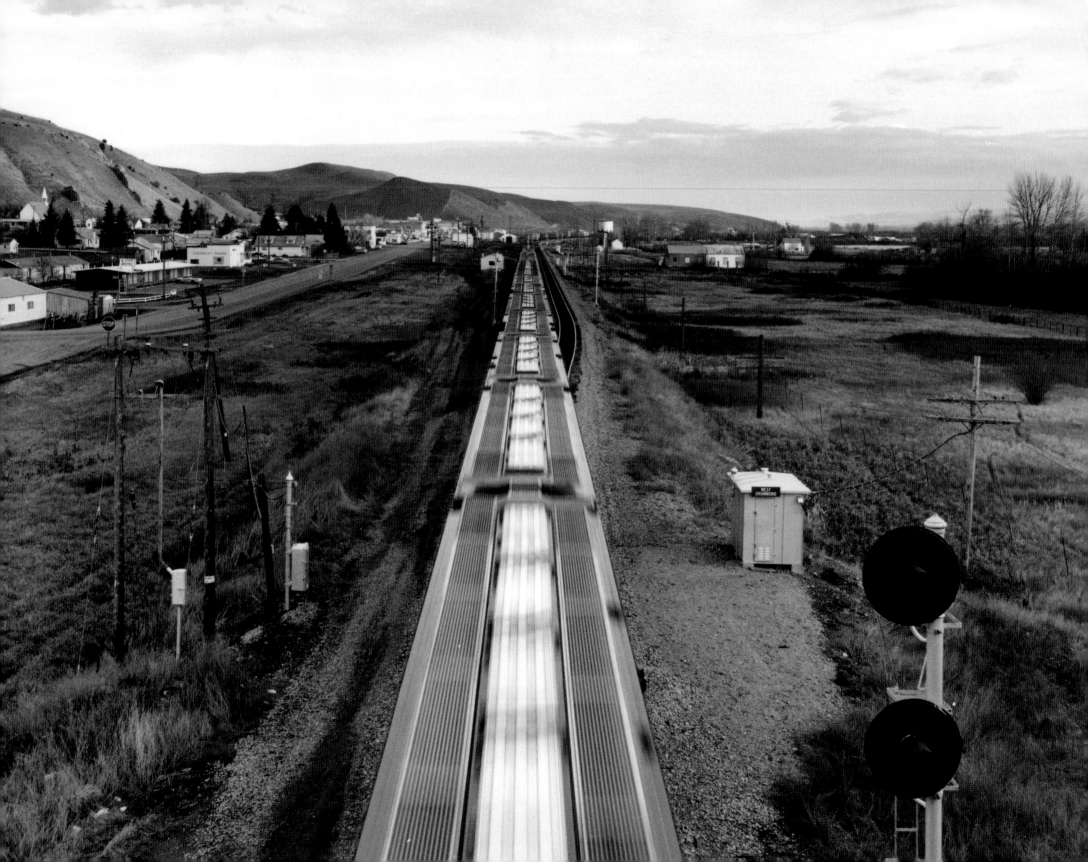

Preface

This project evolved as a result of a visit my husband and I took to Montana in 1991, where we met Jack and Onita Nelson, parents of a friend of ours. Jack spoke about one of his grandsons who will inherit the ranch and how difficult the life is. At the same time he lamented that his only son and other grandchildren were not interested in ranching. That dichotomy struck me, and I thought, in my urban way, that if I returned, I would find a community suffering from the pain and loss of its children and its purpose.

When I came back one year later, however, I found that in reality, these ranchers have an inherent sense of purpose and contentment with life, despite its harshness, which is in stark contrast to what many urban and suburban Americans experience. I was humbled not only by the error in my own assumptions, but also by the grace-filled way in which they live their lives.

I am not speaking necessarily of religious grace, although there is a large Mormon population in Drummond who do live their daily lives conscious of their religious obligations. What I am speaking of is several hundred individuals of many persuasions, who have developed, over several generations, a remarkable communitywide ability to balance what I hesitate to call "traditional values"—like generosity, respect for others, and placing the needs of the community above one's own when necessary—with the incessant demands of an increasingly depersonalized and technological world. And who, to a remarkable degree, have succeeded. These ranchers and their families possess a sensibility and deep understanding about life's meanings that elude many of us. Their conversations reflect their very direct experience of life, describing, rather than questioning, their experience. Much of this, I am convinced, is rooted in working the land—but not all. Some of it is simply them.

Before you begin your journey into this book, I want to say that although Drummond is a tiny community, I did not photograph every soul or even every ranch. Some omissions were deliberate and some unavoidable: People who do not ranch at all, and there are quite a few in

Drummond, are not represented; some ranchers were more shy or more reluctant to participate than others; and some ranches did not transfer well from the physical plane to the photographic image. Also, since completing the photographic portion of this work, some things have changed in Drummond: People have died or moved on, and places of business and ranches have changed hands or ceased functioning. Time has made this a more historical document than it was intended to be, but I have decided to leave it as a slice of life for the years when I was working there, rather than trying to make it a strictly contemporary piece. Thus, despite the alterations in detail, I think that the "whatness" of Drummond is still intact.

Acknowledgments

There are many people who need to be thanked for helping this book come into existence. Gordon Nelson began it all when he urged my husband and me to visit his parents. Carolyn Cunningham published some of my photos in *Montana Magazine* when she was the editor there. Laura Millin, Director of the Missoula Museum of the Arts, gave me a show at the museum, affording me a wider local audience, and she continues to be a supportive friend. Barbara Racker, former Curator at the Paris Gibson Square Art Museum in Great Falls, also gave my work an opportunity to be seen. Ripley Hugo, an extraordinary poet and human being, has been a steady and powerful influence, not only in my work, but also in my understanding of the "Western mind." Rick Newby, John Nichols, Yvonne Gritzner, Teresa Jordan, Linda Hasselstrom, Kermit Hummel, and Nancy Langway all loved the work even in its rawest stages and gave me courage to keep going. Early in the life of the project, I received significant support from Agfa, for which I am still very grateful. Dara Tittjung, my husband's daughter, designed the book, and her husband, Manfred, did the digital magic. Megan Hiller, my editor, came into my life at exactly the right moment and helped to bring focus and meaning to the written text, and held my hand during the remarkable passage from manuscript to published book. My family put up with me and with my absences, both in Montana and in the darkroom, and cannot be thanked enough for their love and support. But the biggest thanks go to the people of Drummond, and particularly to the Nelsons and the Wetsches, who took me in and made me feel like family.

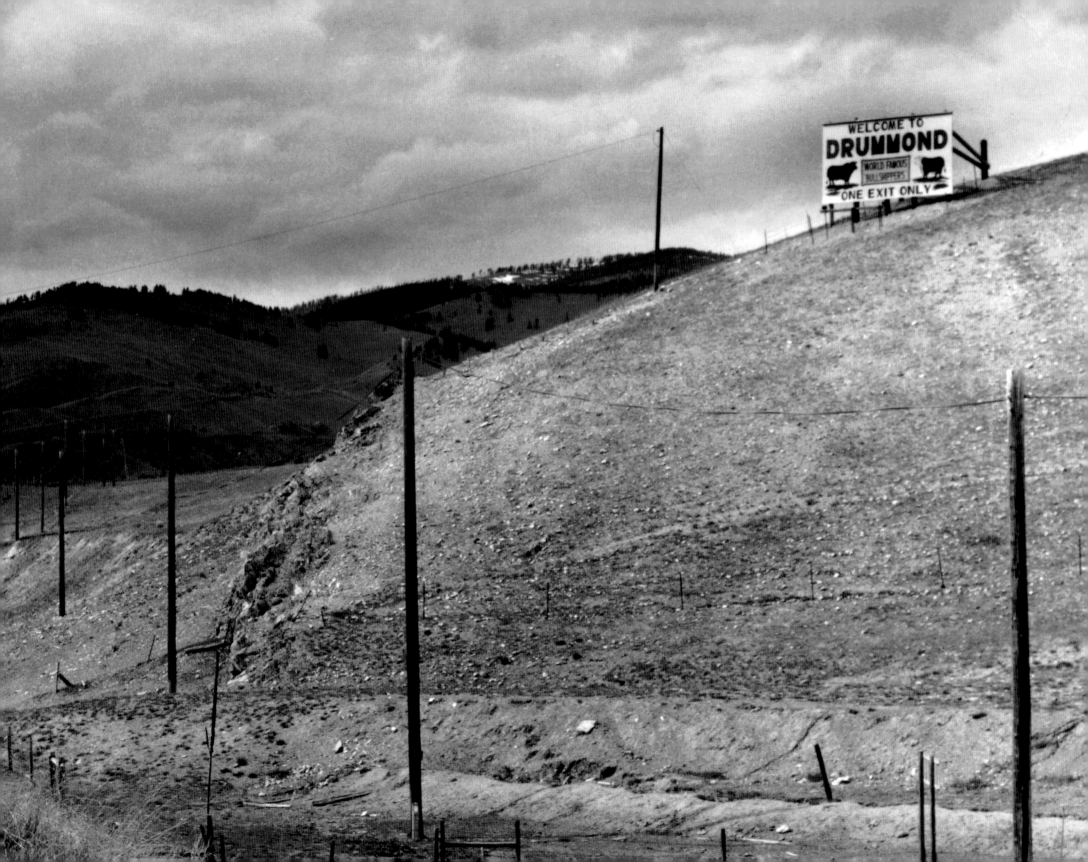

The Town

Two signs sit high on the hillside above I–90—one facing east, about 50 miles out of Missoula, and one facing west, about 70 miles from Helena—WELCOME TO DRUMMOND, WORLD FAMOUS BULLSHIPPERS, ONE EXIT ONLY. If you take that one exit, the Flint Creek Valley stretches to the south where the Clark Fork and the Flint Creek join just out of town, and on a clear day you can see the high peaks of the Flint Creek Range to the southeast. A ten-minute drive south opens panoramic views of the Pintlers, some of the highest peaks in Montana, and a five-minute drive north through the canyon brings you into the high country of the Helmville Valley, with the snowcapped Scapegoat Wilderness in the distance.

Three miles to the south of town, you can still see what is left of New Chicago, the original settlement town in the valley. New Chicago was created along the Mullan Trail—one of the major east–west Montana wagon trails—and was a thriving stage town until the Burlington Northern Railroad laid their tracks at the northern end of the valley in 1883. As early as 1871 there was a camp called Edwardsville at the north end of the valley, named after a local rancher, John Edwards. But it wasn't until the railroad came in that the fate of New Chicago was sealed. The railroad renamed Edwardsville Drummond Camp after a more colorful man, Hugh Drummond—a trapper who made his camp where the train station is now. In 1883 the first cattle were shipped; in 1884 the post office opened and the name was shortened to Drummond, and by 1890, even John Featherman, one of the founders of New Chicago, had moved his general store north to the new town.

The Chicago & Milwaukee Railroad laid a second set of tracks about 100 yards south of the Burlington Northern in 1908 and joined the cattle and people moving business; because the raised beds of the tracks were laid in the flood plain of the Clark Fork, a raised boardwalk connected the two stations. Before the last cattle train left Drummond in 1968, countless gas stations, hotels, barbershops, a Chinese restaurant, and saloons came and went, thriving on the business created not only by the ranchers who brought their cattle to town for shipment, but also by the itinerant workers (termed "bums" by the locals) who came each summer to help with the haying.

Today there is very little evidence that the Chicago & Milwaukee tracks were ever there. Most of the establishments catering to the cattle producers and transient workers are gone, and the cattle are shipped by truck, a faster and safer way to transport live animals.

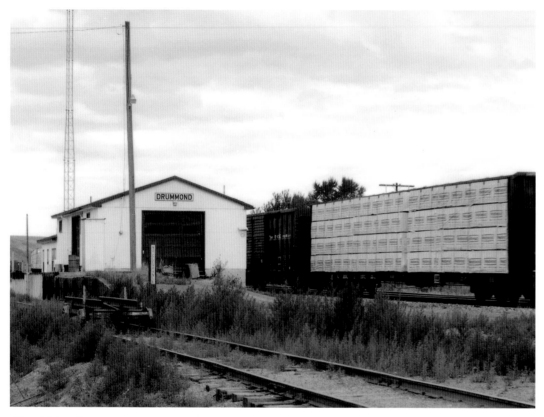

The old depot

When I first came out here, this town was really booming. There were eleven bars and three grocery stores. All the cattle were brought to town and were shipped by train. There were also four passenger trains stopped here every day. Plus, we had twenty-eight buses a day going through here, and the bus station was open twenty-four hours a day. Now we have one bus a day in each direction, I think, and the trains don't stop here at all anymore.

—FRANCES STACY, WHO OPERATED THE BUS STATION IN THE EARLY 1950S UNTIL SHE LOST HER HEARING

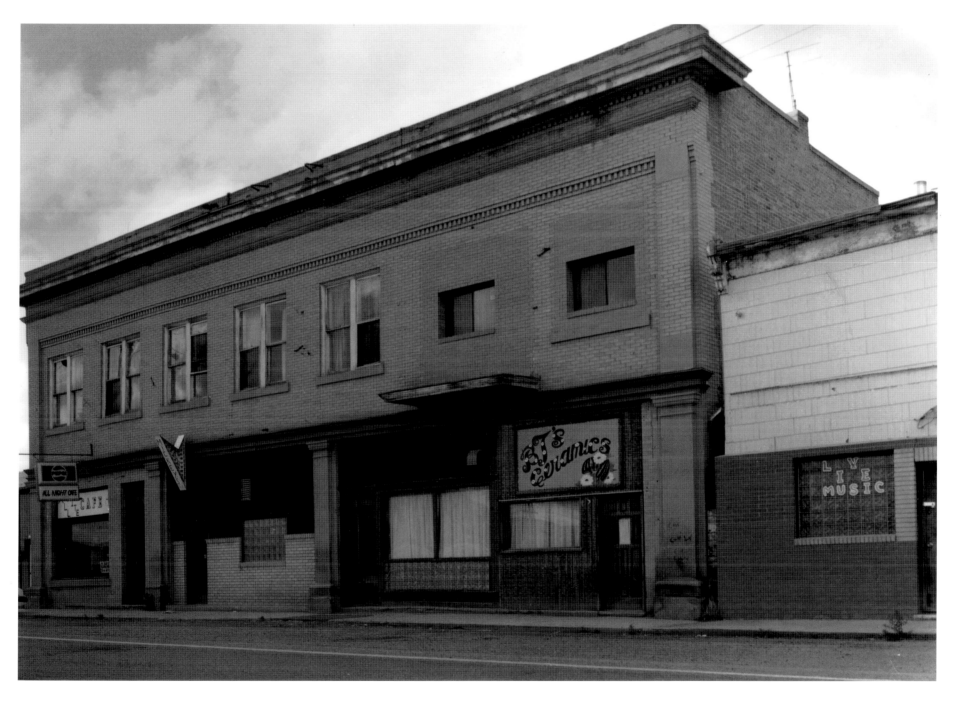

The old hotel and All Nite Cafe, Front Street

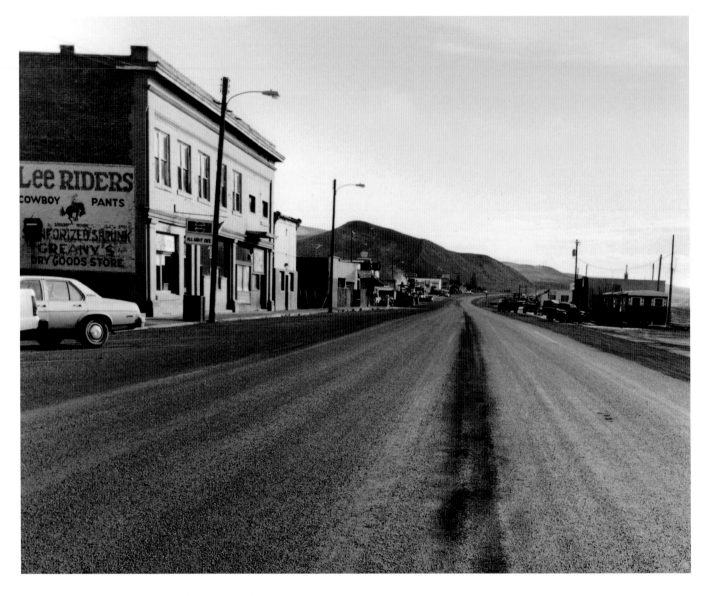

Looking east along Front Street, from one end of town to the other

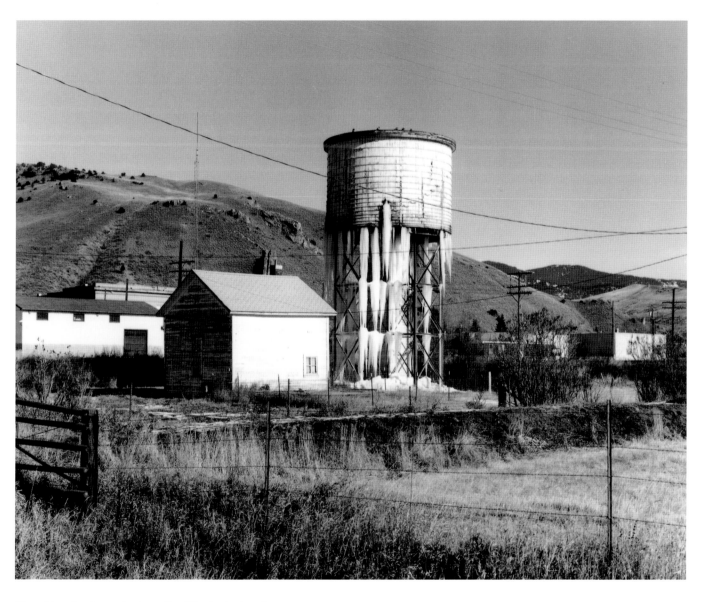

The old water tower just south of the train depot

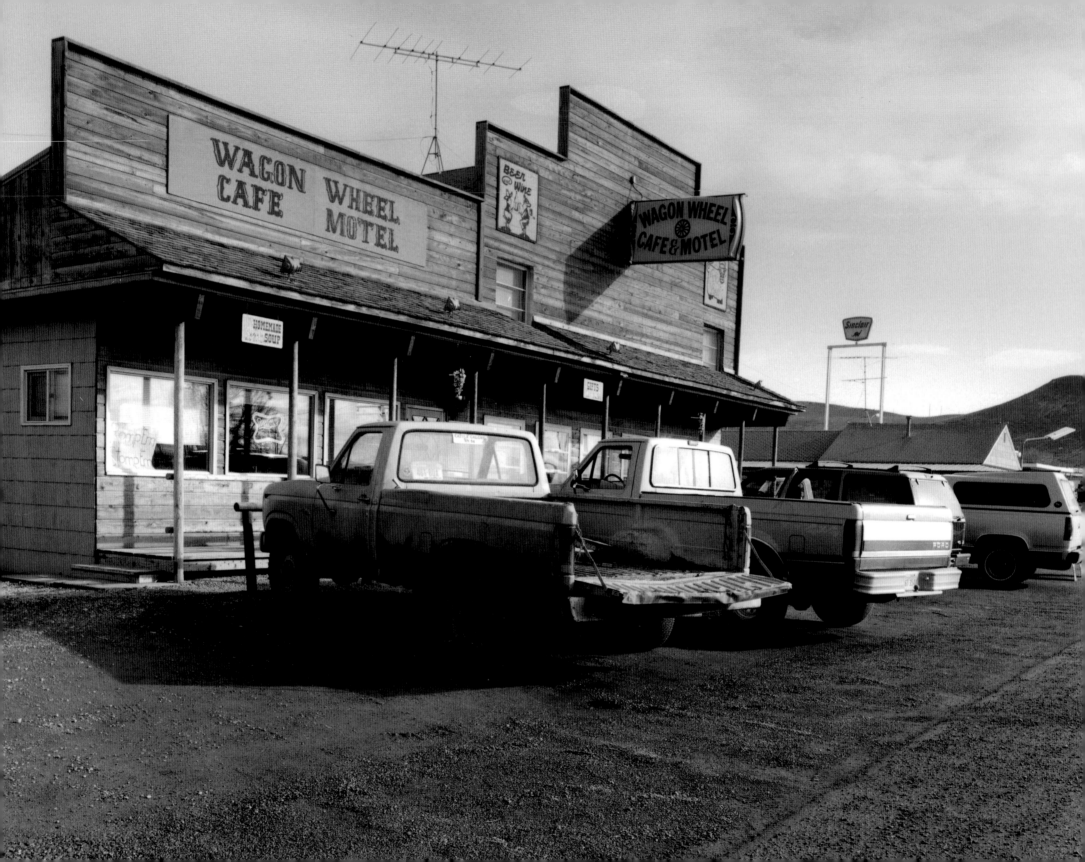

Facing page: The Wagon Wheel Cafe on Front Street, at the east end of town

Right: Although the Wagon Wheel is not the only place to eat in town, over the years, and despite changes in ownership, it has become a central gathering place for meetings and socializing. Throughout the day, hunters (like the men pictured), loggers, truckers, and tourists stop here. And because it is across the street from Mentzer's Stockyards, Garry Mentzer uses the cafe to complete business with those who are either selling, hauling, or buying cattle from him.

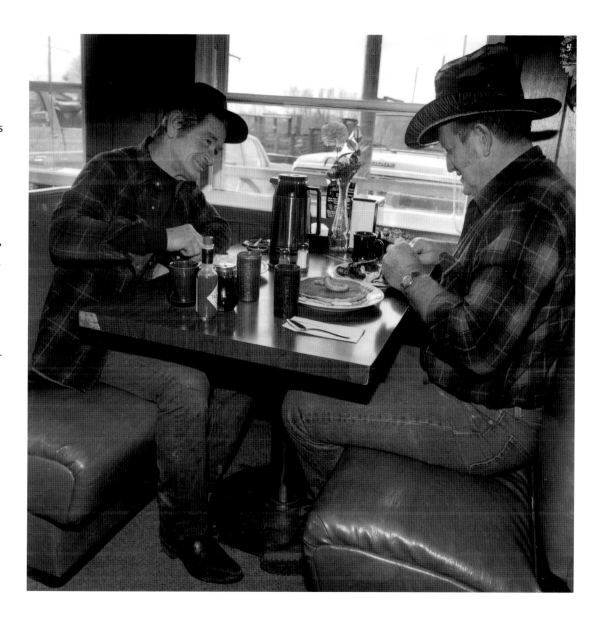

always liked brands. I like to draw them and had everybody's brands memorized. I did a lot of riding, including with a brand inspector, who said to me one day that they needed another brand inspector and that I should apply. When I went around and had to get signatures from ranchers, I know they only saw me as the preacher's daughter, and so some of them looked at me really funny—but they signed.

Then Garry Mentzer was the best to give me a chance. At first I did his little jobs, where there wasn't much money. But after a couple of times he decided I was all right. The guys treat me real good. I had to get after a couple of them for being really vulgar, but they didn't take offense at all. Since then they ask me to leave if they tell really awful jokes, which I do. But most of the time they tell moderate jokes, and I listen to them and add a few of my own. They treat me like a lady.

The only problems come from the truckers coming in who don't know me or anything about me. They just look out there and see a girl doing what a man's supposed to be doing, and they can be really obnoxious. The guys here, though, stay between me and the truckers and don't let them near me. One truck driver was making comments about me out in the yards while I was out sorting cattle and Jack Nelson was there and told him, "If you say one bad thing about her, you'll have half the cowboys in the valley on your case." That was really nice of him.

—SUSAN OSTLER, ONE OF A HANDFUL OF WOMEN BRAND INSPECTORS IN MONTANA

Facing page: Susan with Ron Wetsch, Jack Nelson's son-in-law. Susan works at Mentzer's Stockyards across the road from the Wagon Wheel Cafe.

Swede Nelson, Jack Nelson's half brother, got the first liquor license in Granite County in 1933, right after Prohibition. So basically, that bar's been in business for sixty years, and it's only had five owners, including Greany, now. There's been some interesting people and every walk of life in there. The things I remember most are the parties and Rocky Mountain oyster feeds and birthday parties we've had there, where the whole town comes. Back in 1978 the rodeo was still huge. On Saturday night and Sunday, the town was completely and absolutely filled. The streets were closed. But even then, Swede's Place always had a reputation for being a nice clean bar. Bad language wasn't allowed, so a husband could bring his wife. It's just always had that reputation. It's the people's bar. You might run it and you might own it, but actually people feel like it belongs to them. And they don't like changes, so if you did anything different, you'd better do it for the better, and they'd better like it. And that's the way it should be.

—BUD WEAVER, FORMER OWNER OF SWEDE'S PLACE

When I came to Drummond in 1951, there were seven bars and fourteen gas stations. Now there's three bars, and one of them is closed part of the time, and there's only three gas stations. Used to be men would come in here on the railroads, in flatcars, and lay around town hoping ranchers would come in and pick them up. Then they'd go haying for six weeks to two months. But that kind of stuff is over. Everybody's started getting more modernized, and now just one man and his son or son-in-law can run a whole place. For our business, here, we have to rely on the timber industry quite a bit. But now those guys are having a heck of a time getting enough timber to cut, and they have to haul it a long ways, so they're having a pretty hard time, too. And the phosphate mine's laid off seventy-five to eighty men last year. So it's pretty slow here. But it will pick up. It always does, always since I've been here. One thing is, it can't get much quieter and still have a town, so the only thing we can look for is for it to get better.

—PAUL GREANY, CO-OWNER OF SWEDE'S PLACE

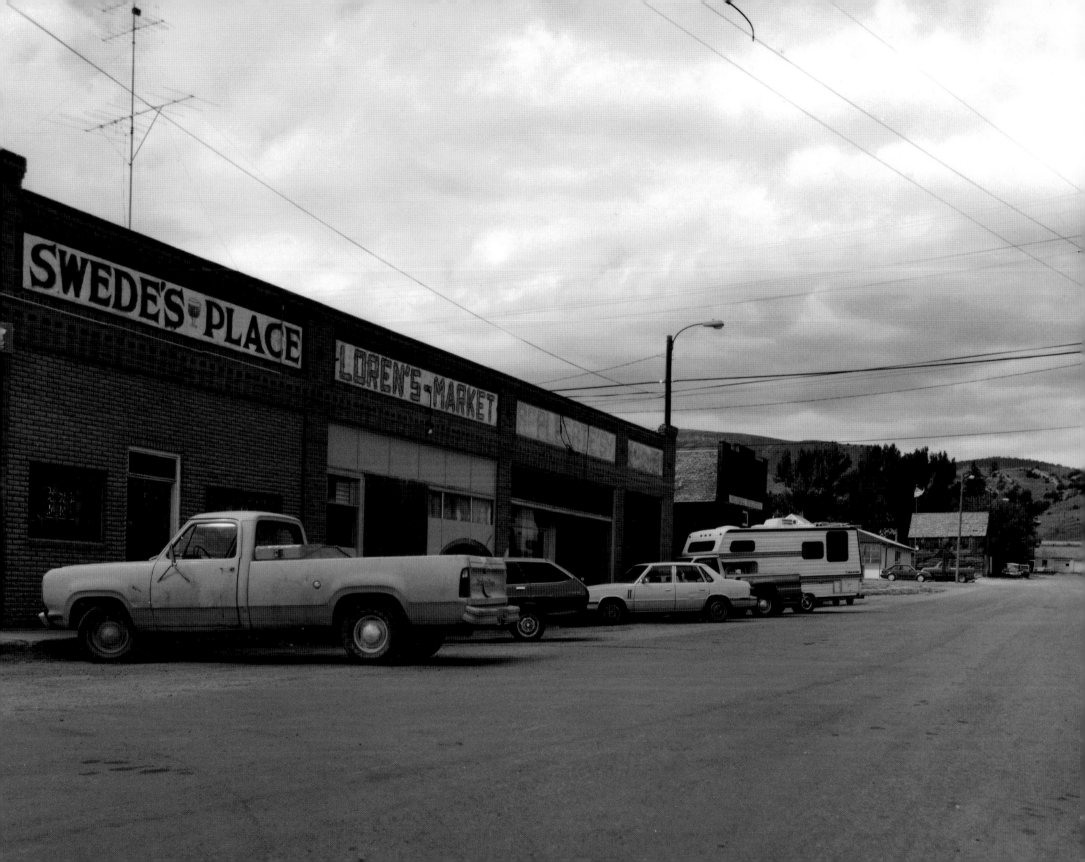

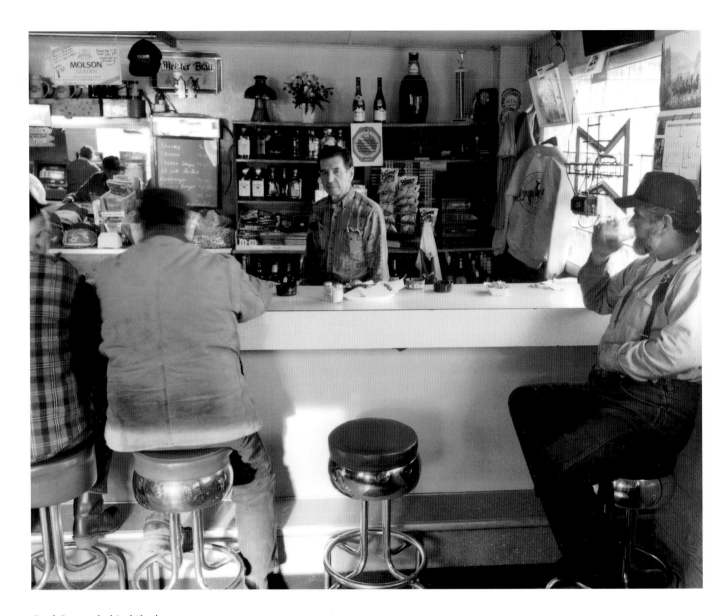

Paul Greany behind the bar

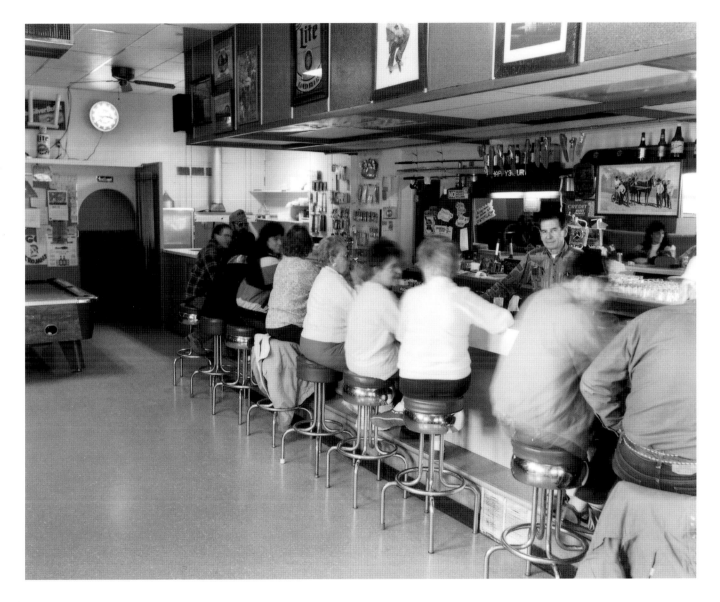

Swede's Place, late afternoon

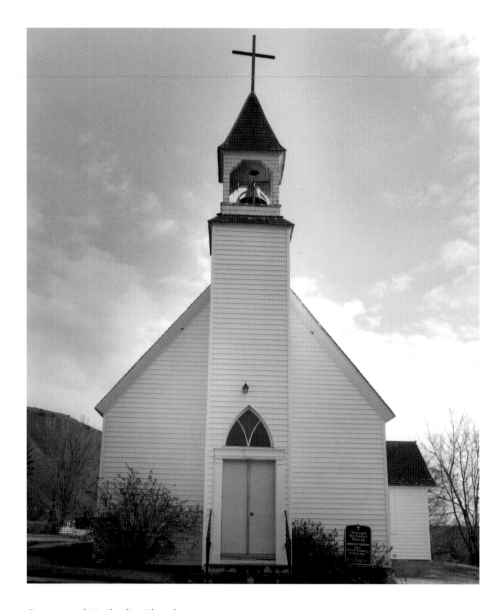

Drummond Methodist Church

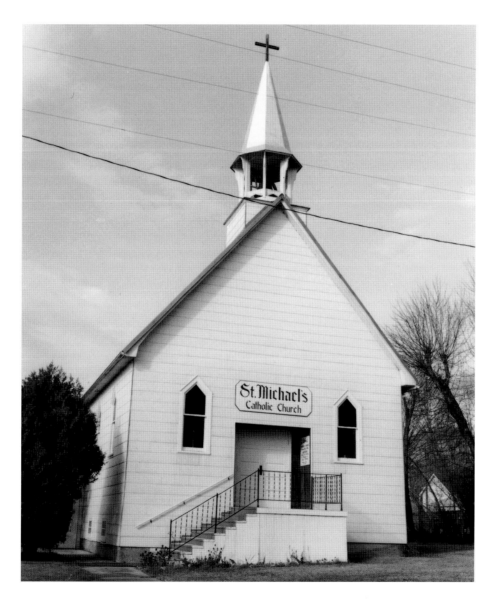

St. Michael's Catholic Church

Mormons comprise about half the population of Drummond. Their work ethic and general abstention from drugs, alcohol, and stimulants provide a powerful positive force. There is no proselytizing; this was something that the first Mormons, who came in 1915, agreed to as part of the condition of being allowed to purchase land. As a result, there is a comfortable mingling of all faiths, which in turn has created a very strong sense of community—something that everyone is proud of.

I remember on the first night I was in Drummond the Nelsons took me to a supper at the Mormon Church. When I asked them if they were Mormon, they said, "Oh, no. But everyone goes to everyone else's church suppers. And the best ones are at other people's churches, where you don't have to cook or clean up."

The Church of Jesus Christ Latter-Day Saints, just south of Drummond on Old Route 10A. Left to right: Bill Wise, Rick Lacey, and Charlie Parke.

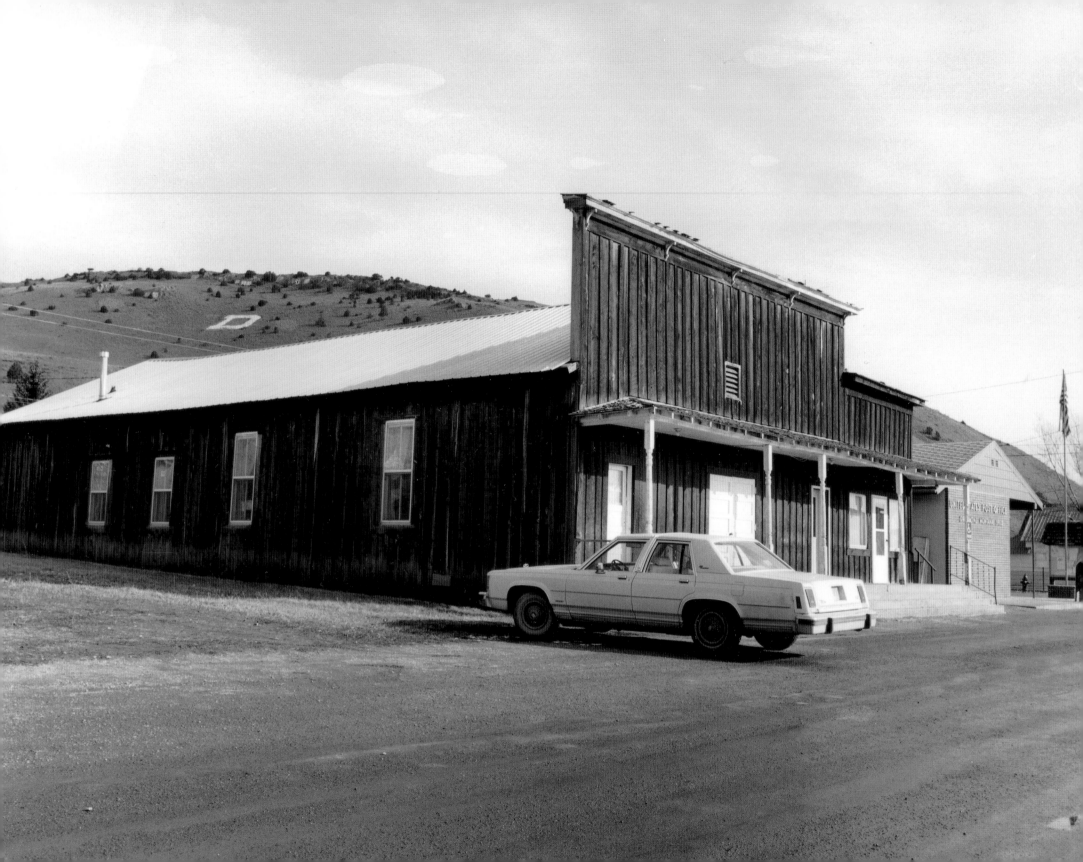

Facing page: Almost all of the major functions of the community—birthday parties, anniversary parties, weddings, engagement parties, fund-raising events, senior citizen meetings, and dances—are held in Drummond's Community Hall. Announcements for these events are carried in the local papers. Years ago, when dance bands would go from town to town, the Drummond Community Hall was considered the finest dance floor in western Montana.

Right: Butch Friede holds up a sculpture by May Nelson at the Cowboy Casino Night auction at the Community Hall. The Casino Night benefits the children's cancer Make-A-Dream camps.

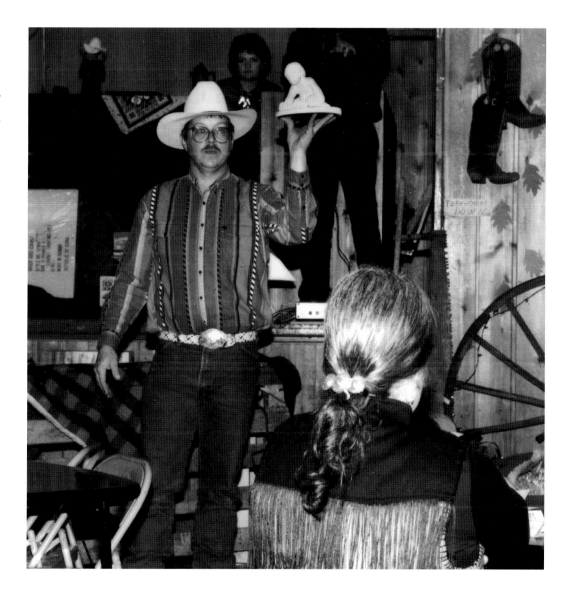

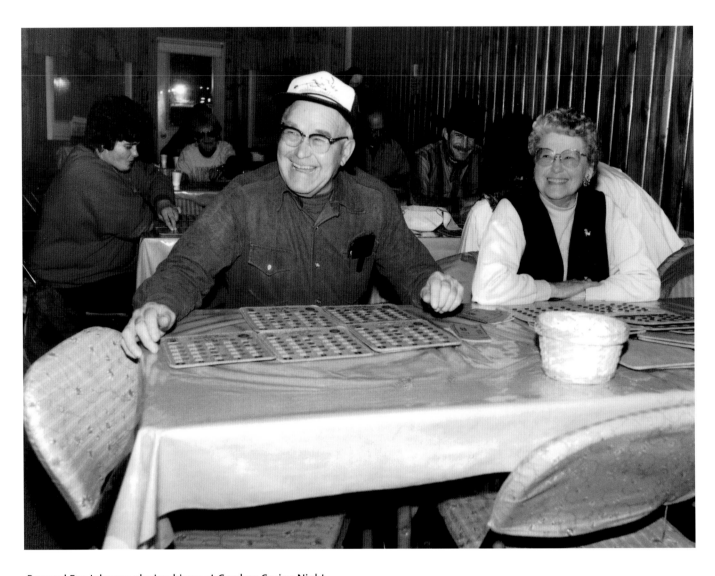

Roy and Eva Johnson playing bingo at Cowboy Casino Night

B asketball is big in Drummond. I think it's because at that particular time of the year it's kind of a lax time before calving, and people can come out, socialize, and watch their kids or their neighbor's kids play. I grew up only thinking of basketball. There wasn't even girls' basketball then, although for the past fifteen years or so we've had really good girls' teams. But there was always boys' basketball. And it was the thing.

—JOY WETSCH, DAUGHTER OF
JACK AND ONITA NELSON

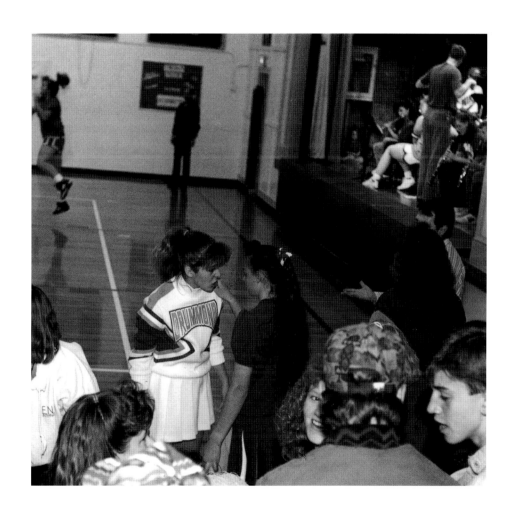

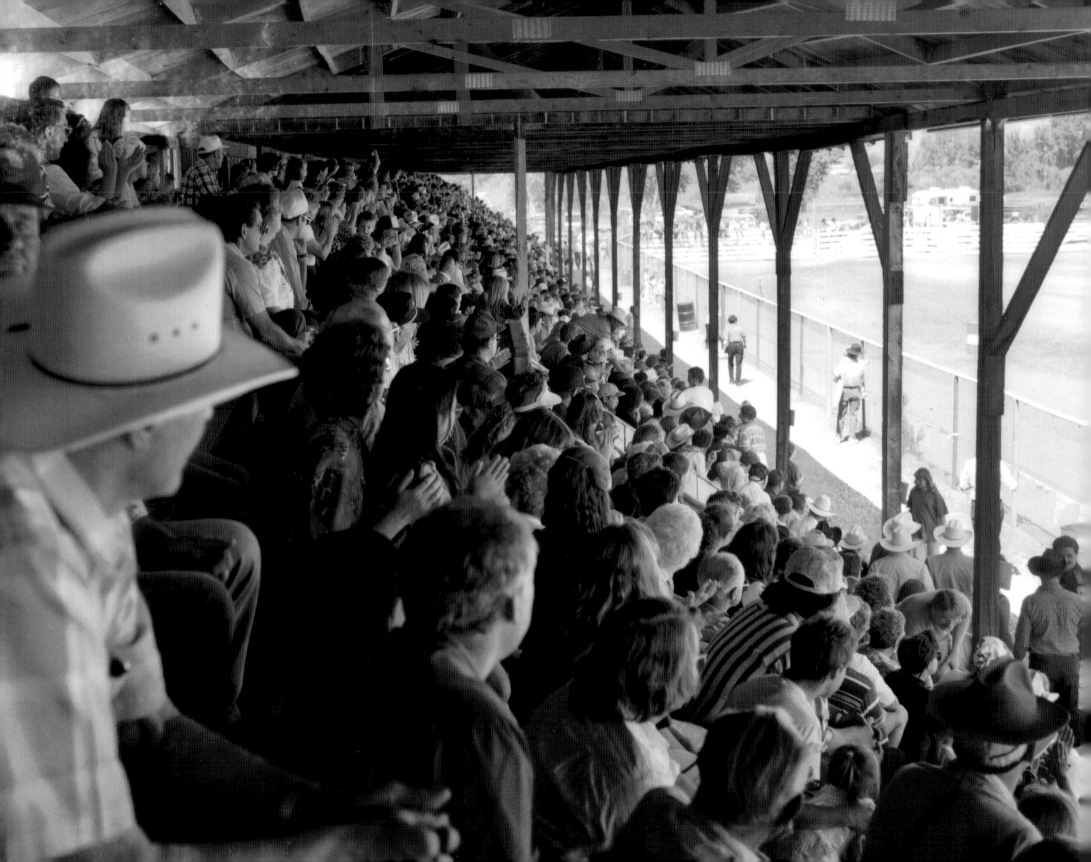

The Rodeo

The Drummond Rodeo has been a summer staple for more than fifty years. According to Jack Nelson, the first rodeo was held during World War II over the Fourth of July weekend on the street at the upper end of town. "There weren't any buildings there then. They just saddled some horses and bucked them out." After that the rodeo grew into a more organized event; the rodeo grounds were built, and finally someone was hired to run it. For years the rodeo was such a major happening that the main street of town was closed during the weekend and there would be dancing in the streets all night. Local riders were the main participants, and the community was very much involved in cheering on their own.

Now, although the Drummond Kiwanis Club sponsors the rodeo as a fund-raiser, it has become a small-scale PRCA (Professional Rodeo Cowboy Association) event with riders who have no connection to the community looking to win enough points to compete in the big purse rodeos. The date has been moved from the Fourth to the first weekend after, so that it can fit into the PRCA rodeo circuit calendar. Participation of locals is limited primarily to a children's parade held the day before, and although the town is filled with people, traffic flows as usual through the streets, the bars close at the usual time, and by the end of the afternoon

of rodeo day, Drummond has returned to business as usual. Yet despite the removal of community participants, the Drummond Rodeo is considered by most of the PRCA cowboys who ride there to be the closest to an authentic Old West rodeo that there is, and one of the most fun to participate in. The people of Drummond are aware that their rodeo is different from others, and they take great pride in being able to offer these itinerant circuit riders a taste of a real working-cowboy community.

If you wander back to the chute area, one of the first things you notice about rodeo riders is the relationships they have to each other and their rabid loyalty to their trade. Boys with broken limbs, knocked-out teeth, and wired jaws stay with the circuit, anxious to compete again, no matter how serious their injuries. Many of these riders dream of "going to cowboying," if they survive. Death is part of what they can expect, and it is part of the adrenaline that drives them.

What also drives them, though, is something much more connected to the West itself. Even though rodeo riding is now mostly a professional event—an entertainment—at one time it was an opportunity for working cowboys, many of whom were itinerant, to strut their stuff, to be part of a community, to meet and impress the ladies, to belong, even if only for a

few hours, to something larger than themselves. The rodeo is, in many ways, the vestigial remains of a time when cowboys made ranch life possible, when they were a rancher's salvation.

As the rodeo moves further away in time from the reality that spawned it, the most popular event has become bull riding, something that was never a function of cowboying and which is done, for the most part, not by cowboys but by riders who are pejoratively called "athletes." Wandering around the rodeo grounds in this working-cowboy community, though, you can still sense the pull of the old connections. You can see it in the pride these skilled horse riders take in their fancy dress outfits. And you can feel it in the joy of the audience at seeing daily tasks raised to the level of art.

*B*asically, our Kiwanis club deals with everything from spiritual aims to community service. The majority of our time and money, including the rodeo, usually goes to the schools in either Drummond or Hall, but we also made the original Bullshippers signs for the community, and maintain them as well. In a small community like this, we take anyone who's willing to pay dues— business people or ranchers. We hope people come to all the meetings, but if anytime your family or your job interferes, we understand. You get into those big clubs in Missoula, they fine you for not being there. What they do in big cities doesn't really pertain to our community. They're looking for big business people, professional people. They come in suits and ties. It's not like that here.

—RON WETSCH

Facing page: Seated: Bob Lund, Lowell Bradshaw, Paul Greany, Jim Morse, and Bill Haft. Standing: Calvin Mentzer, Ron Wetsch, Greg Schroeder, Butch Friede, Al Gustafson, Walt Piippo, Lawrence Fickler, Jack Nelson, George Richardson, Kenny Kane, Jerry Olson, and Dr. Tom Linfield. Back, center: Sam Weaver.

Following pages: Men from the Kiwanis Club assemble the chutes for the rodeo.

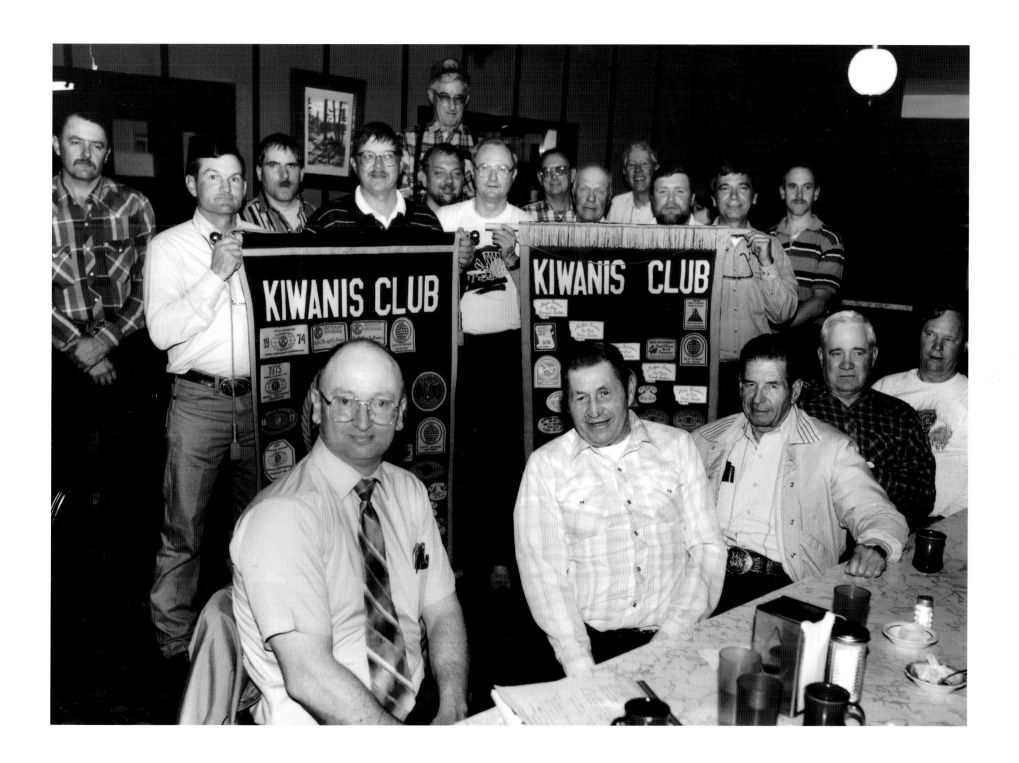

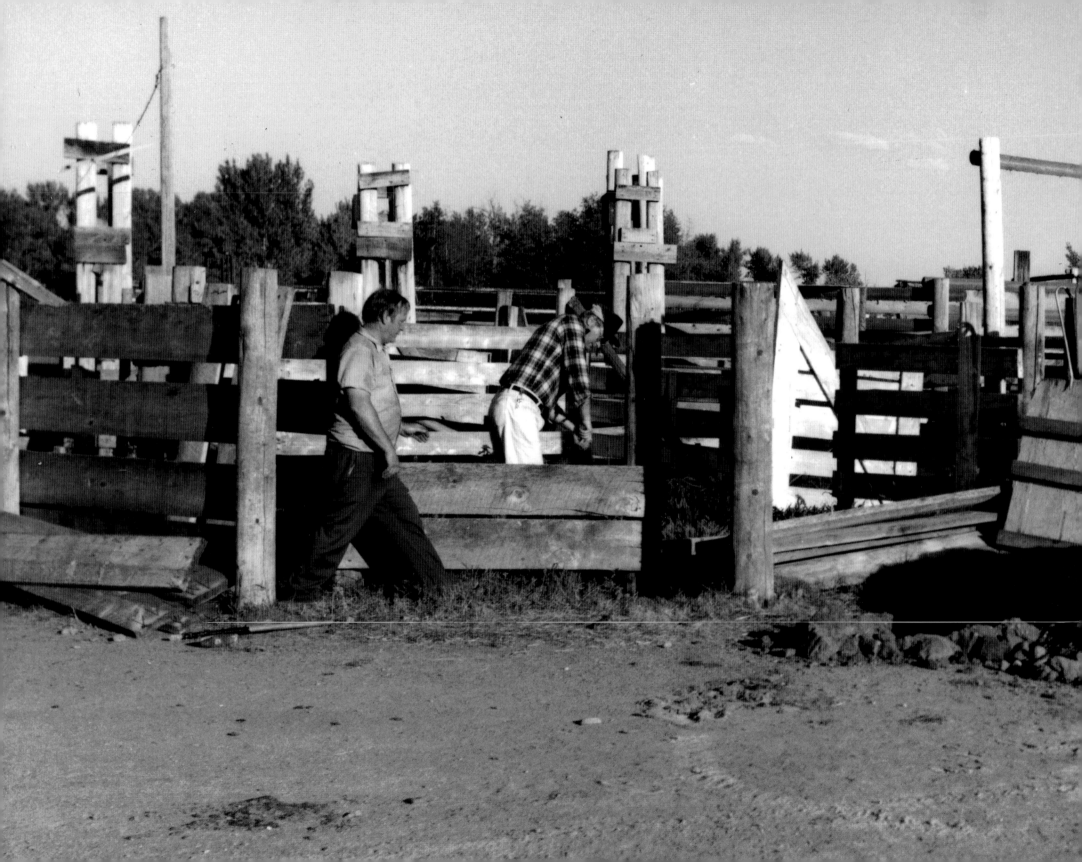

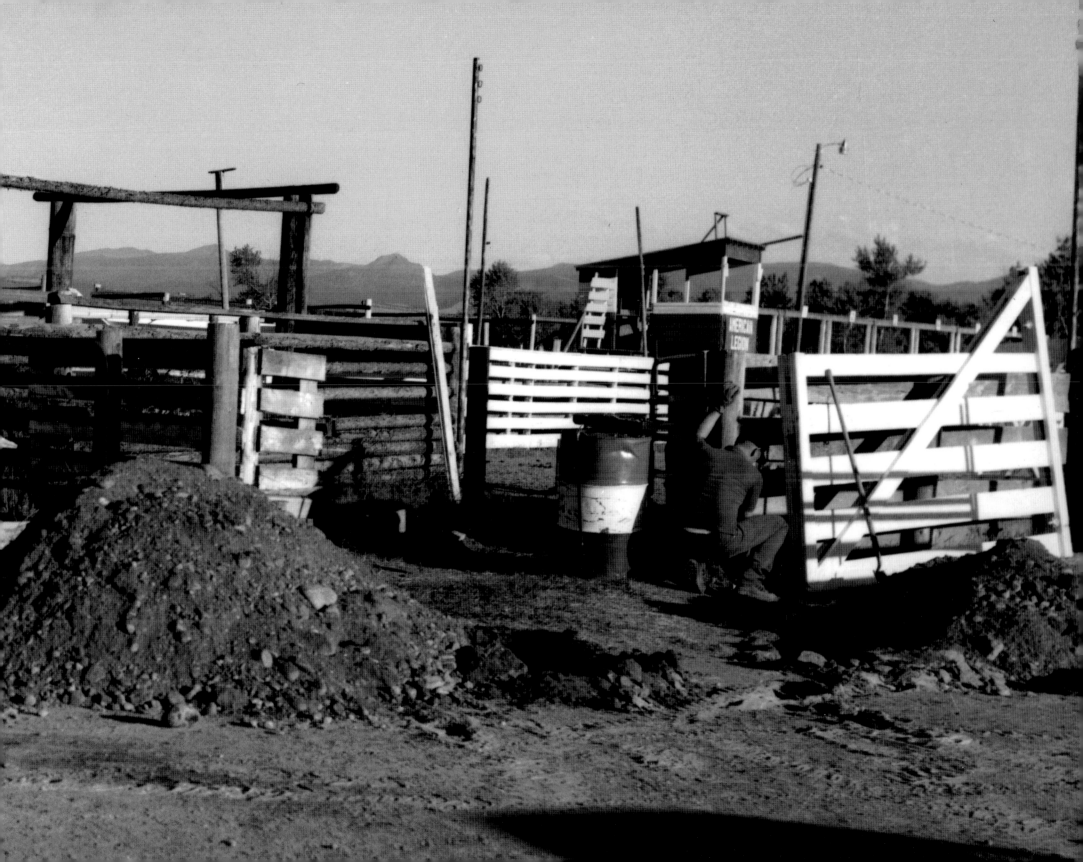

Left: The Children's Parade takes place the day before the rodeo.

Facing page: The honor guard brings the rodeo into town.

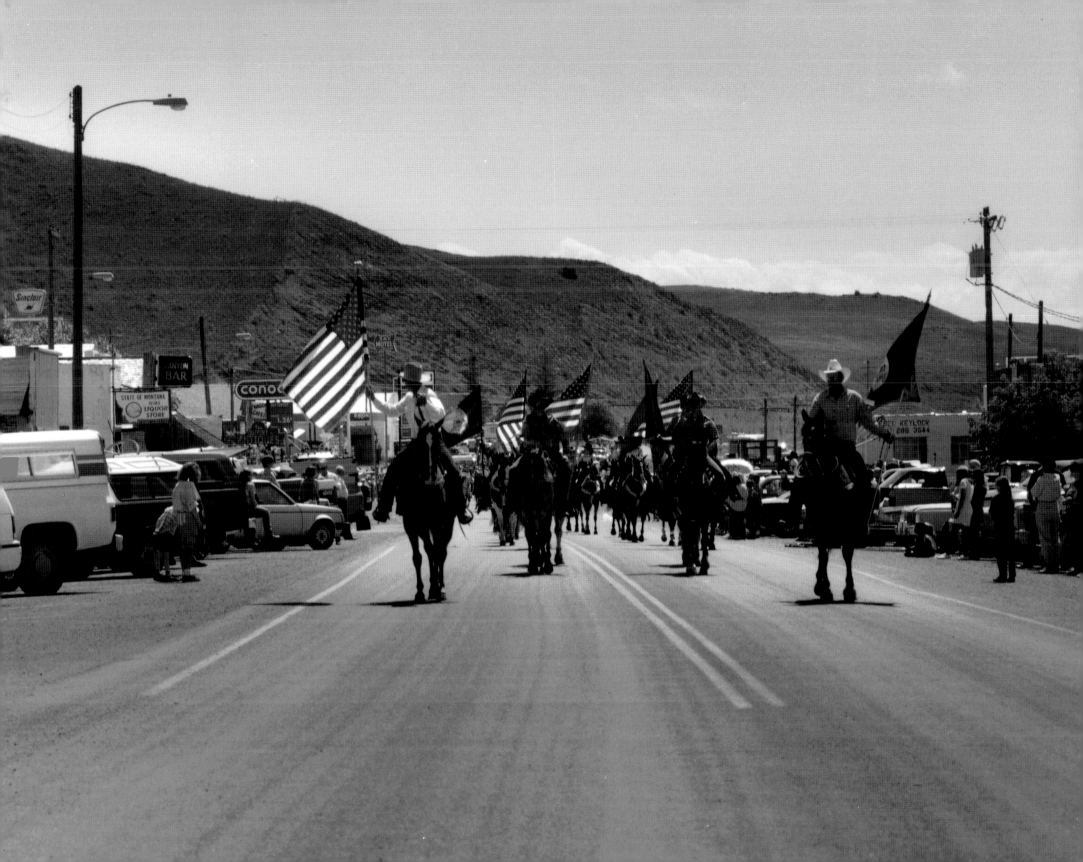

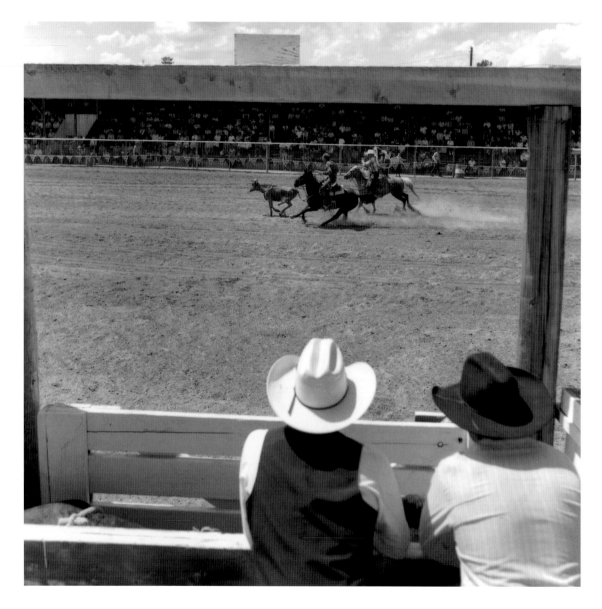

Steer roping

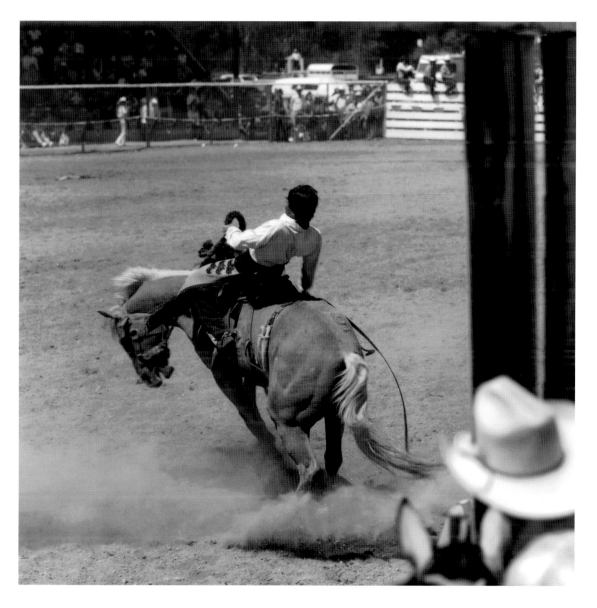

Bucking horse event

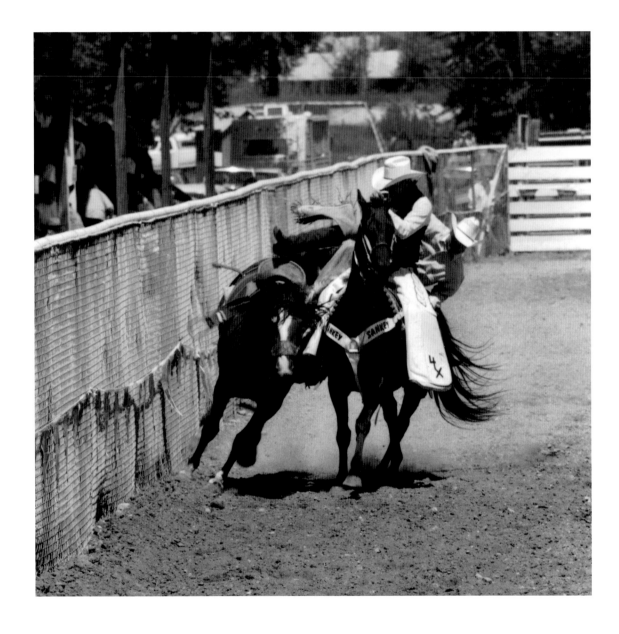

The pickup men perform a variety of tasks in the bucking horse events. If the rider stays on for his eight-second ride, the pickup man comes up alongside the bronc rider, grabs him, and swings him up behind himself.

If the rider is thrown, the pickup man goes after the horse, allowing the cowboy time to move out of harm's way.

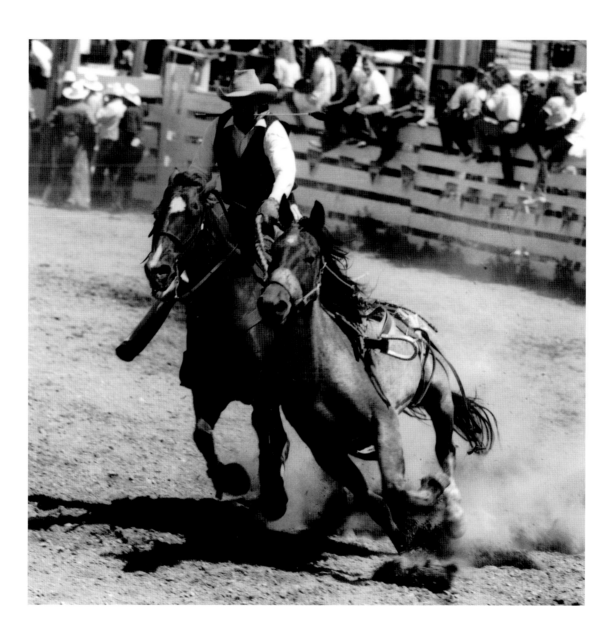

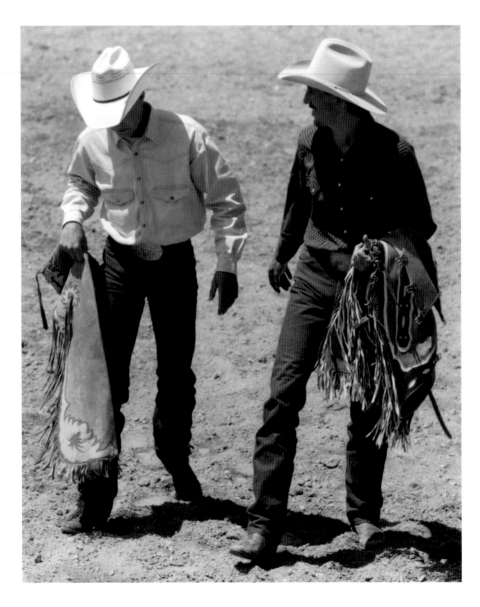

Thrown bronc riders

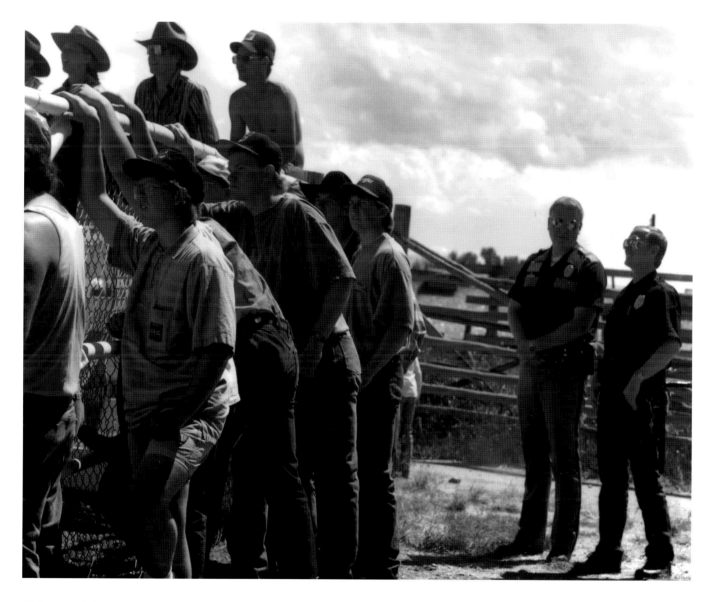

Rodeo spectators

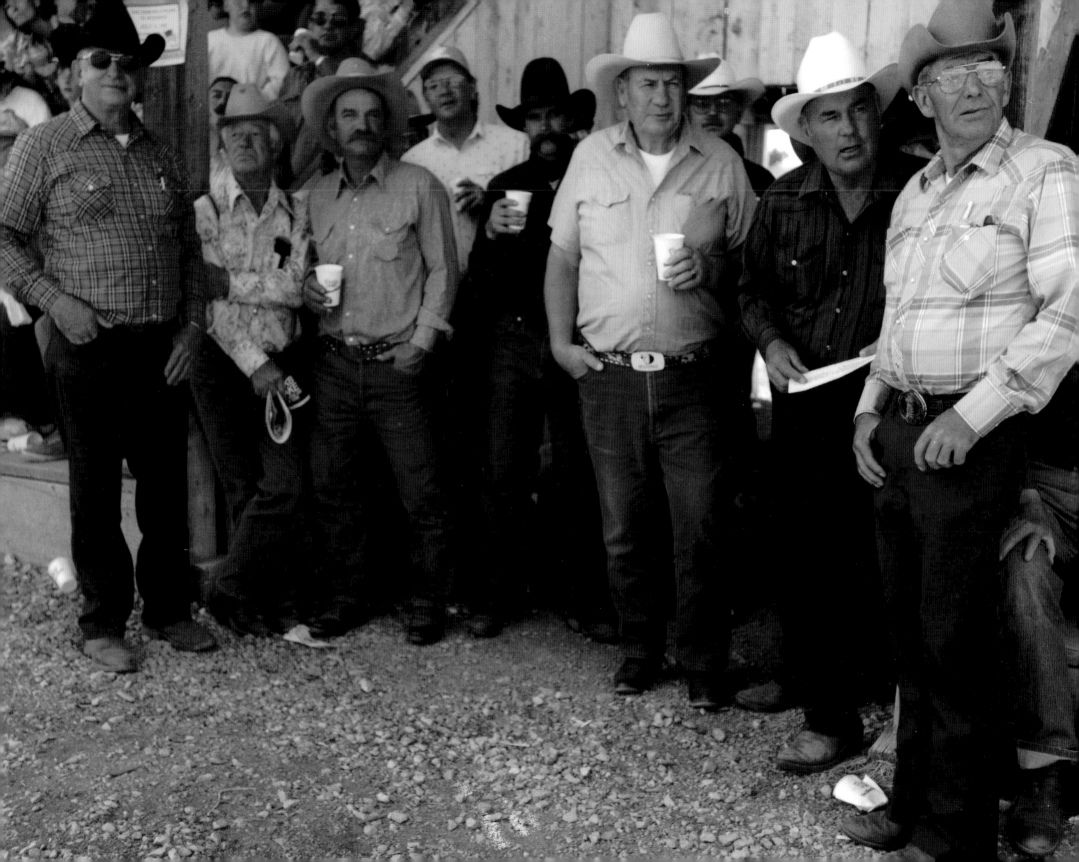

Facing page: Rodeo spectators

Right: The bull pen

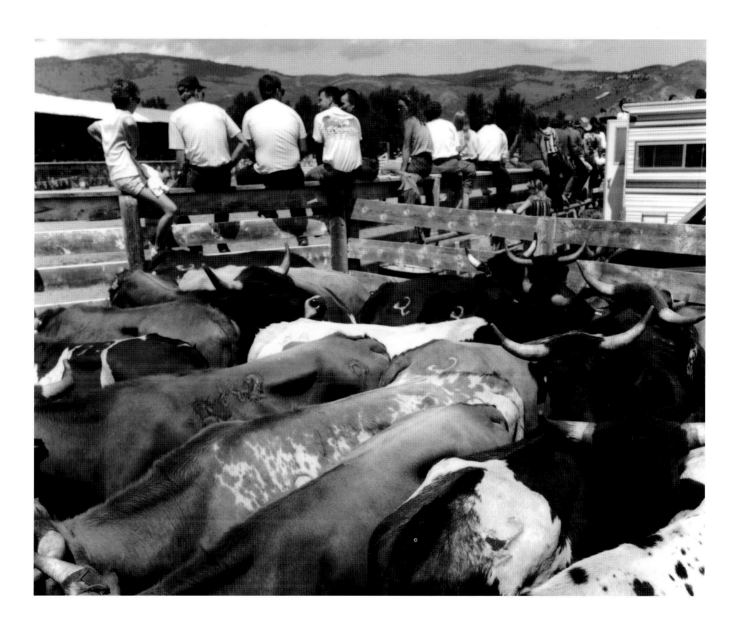

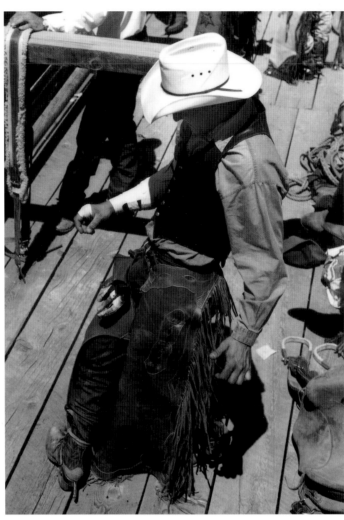

Left: Limbering up

Facing page: Bull rider with his trophy belt buckle

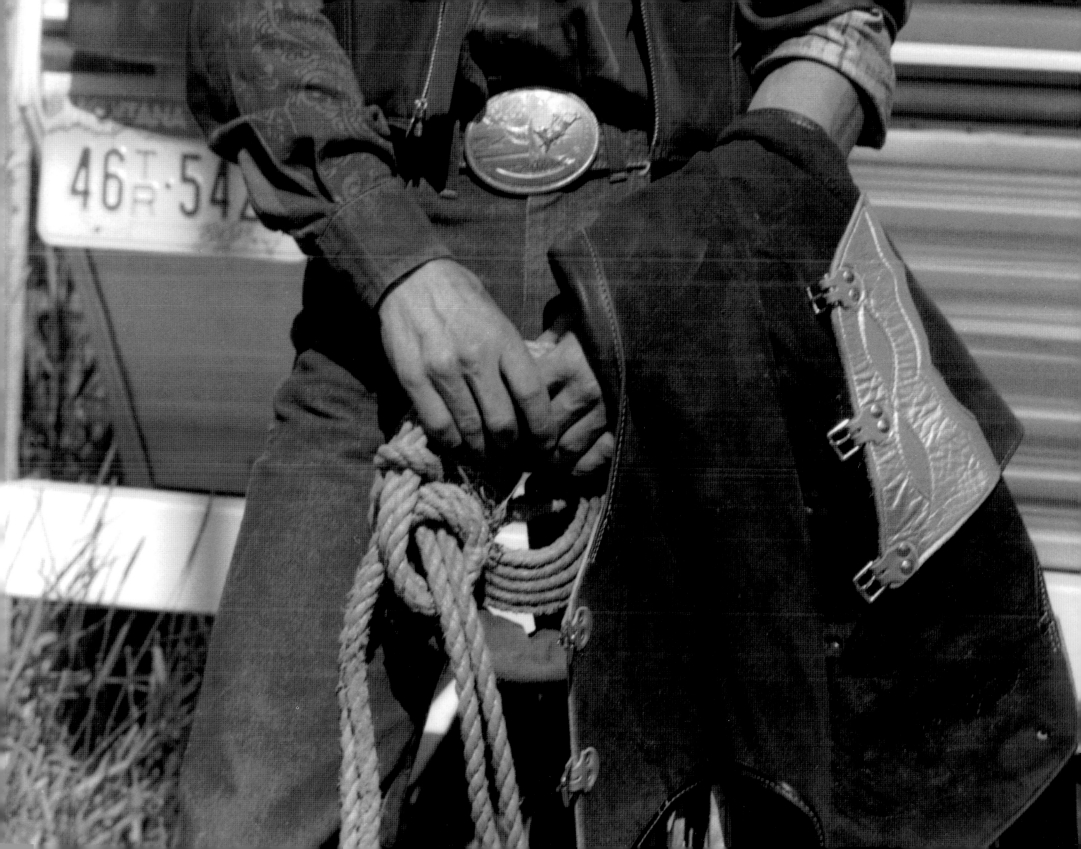

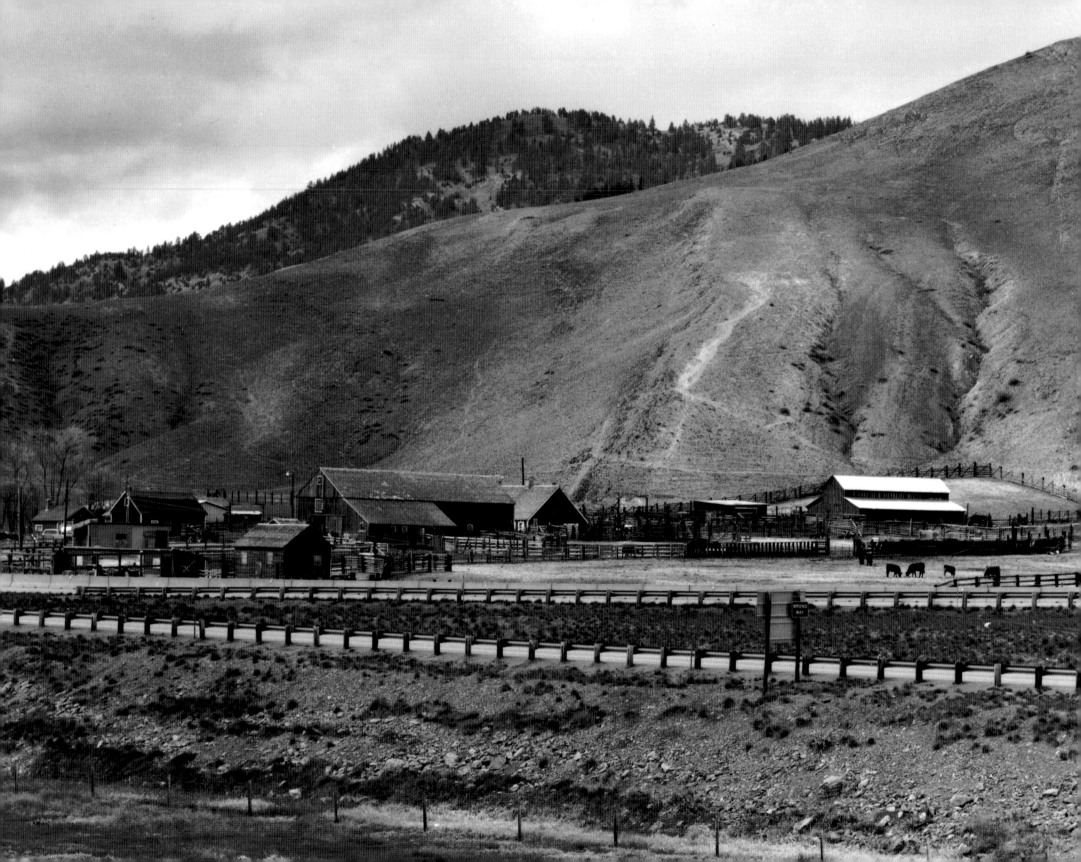

The Ranches

Although a traditional ranch is a family-owned and operated business, when it works well, it is more like a living organism. And like any living organism, it works best when all its interconnected systems run smoothly. There are the day-to-day activities of feeding and tending the animals, maintaining the machinery, keeping the accounts, cooking, cleaning, and raising the children. Sometimes someone may have to work outside the home as well, to make ends meet.

Throughout the year there are times when everyone is needed to help out with some of the more labor-intensive activities on the ranch. In western Montana calving usually begins in late January or early February and continues into March. During this time cows need to be checked every few hours, around the clock, and the newborn calves need to be inoculated and ear tagged for identification. When the calves are two months old, they are branded, dehorned, and the males are castrated. As soon as the grass begins to green up, animals are moved from winter to summer pastures. As spring turns into summer, irrigation lines are started up. By early July the first hay is cut, dried, and baled; in good years there is a second cutting in August. Starting in September, calves are weaned, sorted, loaded, and sold. And then, beginning in late October, cattle are moved back to their winter pastures. Then there is a pause before the cycle begins again.

While many of these tasks tend to fall along traditional gender lines, not all do, and it always amazes me to see how equally and respectfully men and women treat one another. Also, living and working in virtually the same space, where everything tends toward transparency, requires a certain kind of sympathetic suspension of judgment. This is not to say that things always work out perfectly—that people don't disagree or get angry. But in general there has to be certain level of rhythmic energy for things to operate well, which is not always found in other, more impersonal, endeavors. Finally, ranchers feel a moral obligation to raise their animals properly, so that the sacrifice of life has meaning beyond mere monetary gain, and they can be justly proud of the high quality of what they provide for others.

Facing page: Snead's place nestles in the hills on the north side of the Interstate, west of town.

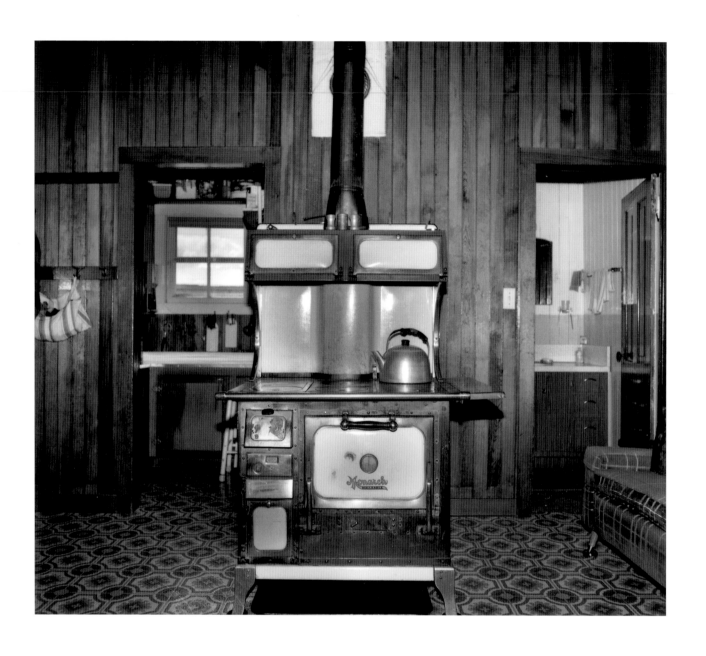

Rozenia Enman

This house was built by my father in 1880, and I've lived here all my life. To look at it, it doesn't look bad, but it can't be insulated. So without this stove I couldn't even live here. The poor old thing was secondhand when I bought it in 1942. My grandmother used to sit right next to it and make braided rugs. But now, I can't even clean it anymore, because I had a slight stroke and my fingers have no feeling in them. Getting old is no fun. I used to be outside all the time, up until maybe ten years ago, mostly with cattle, which I liked. But I can't walk anymore, so that takes care of that. And we sold our cattle, because it was too much for my son to do alone. All I have left, really, is my mind. I do forget things some, but my mind's pretty good.

My grandfather came in 1864 from Canada. I don't know why he settled here, but he must have liked it, because he decided he'd go back after his brother. He walked back but couldn't find him, because his brother had already started out on his own to Montana. It took my grandfather a year to get to there and back, and when he did return, his brother was already here—they must have passed on the way! My husband also walked here, all the way from Prince Edward Island. That's something people don't do anymore.

I remember my grandfather telling stories about the Indians, who were on the warpath then. The old Indian fort was right up here on our place, and there are two Indians buried on the ranch here. I don't know what happened to them, but I think they may have been Nez Percé. When my grandfather told those stories, I was young and didn't listen, so I don't remember what he said. I do remember that the road outside our house was the main road from Deer Lodge to Missoula, that there was a little store here, and a hotel, a beer parlor—a dive, whatever you want to call it—and a little stone house that used to be a Chinese laundry. I played there for hours when I was a kid, because it was just as cool as could be.

—ROZENIA ENMAN

Facing page: Rozenia's ranch is on the old Mullan Trail in what used to be the center of New Chicago. The buildings that she mentions are mostly gone, except for the hotel, which is mostly in ruins. Rozenia died about a year after this interview at the age of eighty-five.

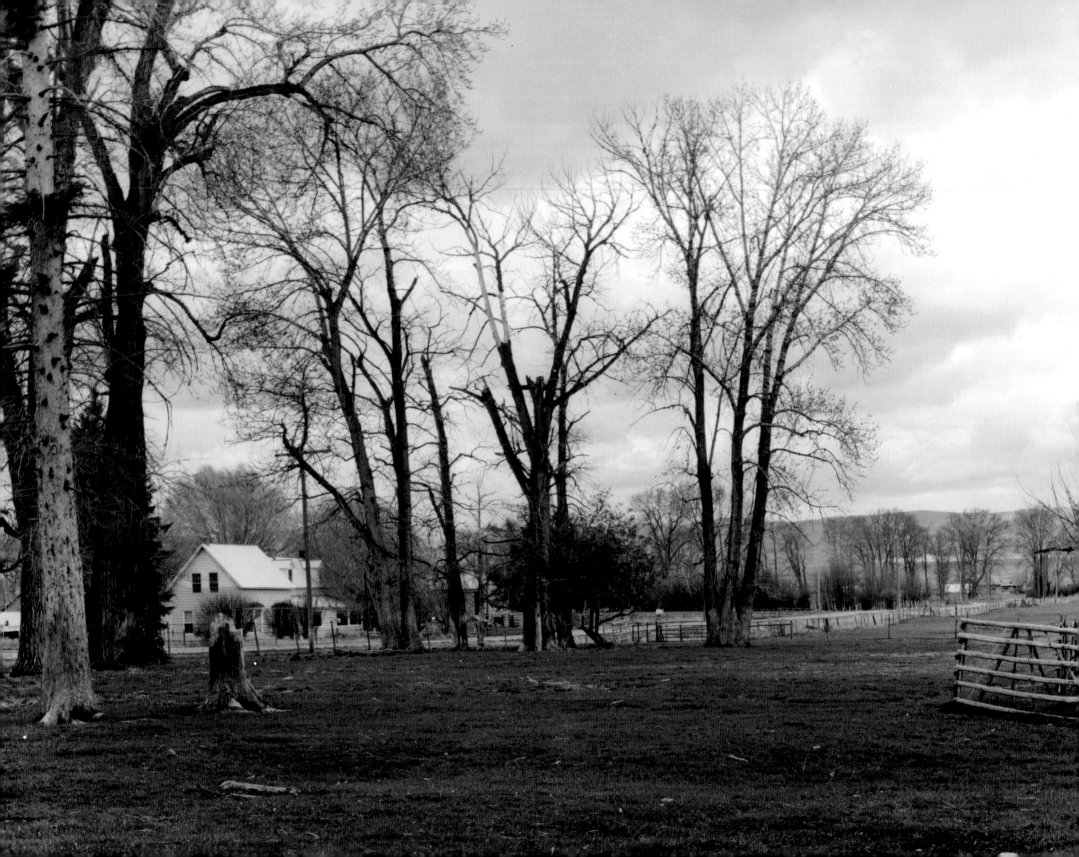

Facing page: Rozenia's house is one of the original homesteads in the valley. The cottonwood trees were planted around the same time that the house was built in 1880.

Right: Across the road from Rozenia's, modern fencing surrounds one of the original apple orchards in New Chicago.

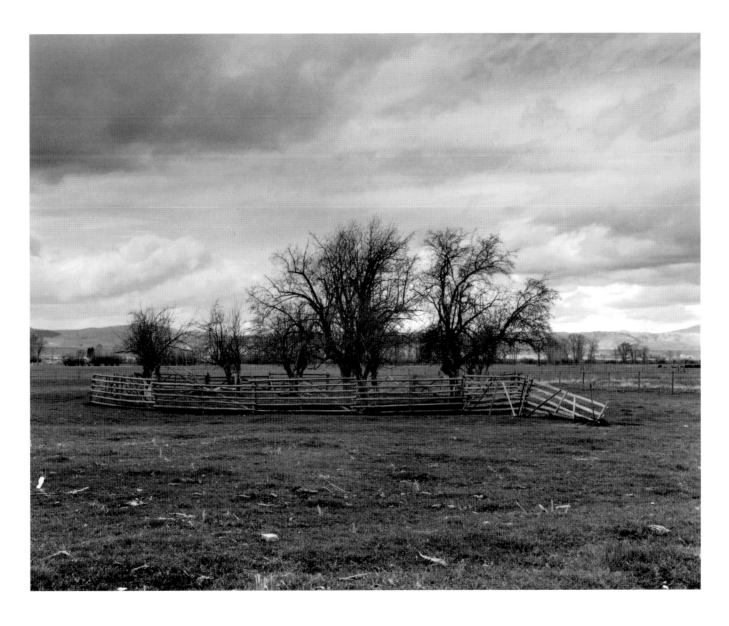

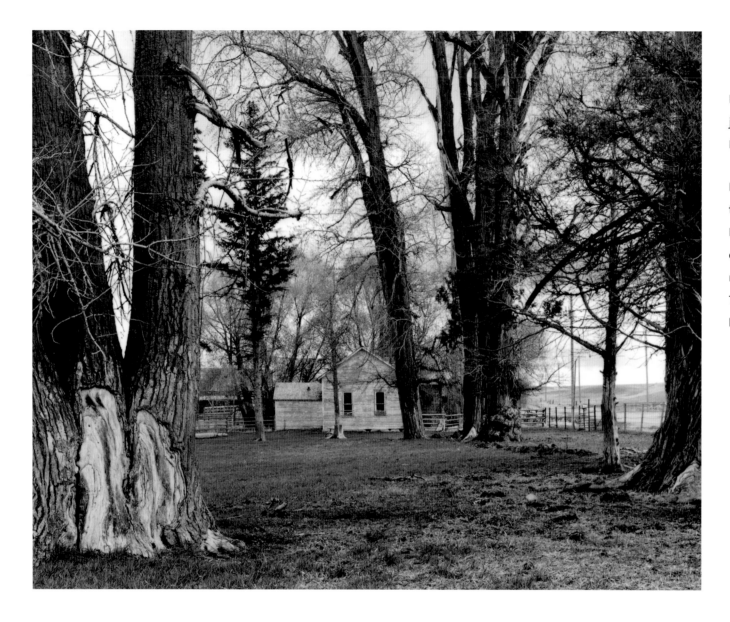

Left: The old hotel remains just down the road from Rozenia's house.

Facing page: The two log houses in the forefront were built by John Featherman, founder of the town of New Chicago. The structures are now part of the Verlanics's ranch. The cabins in the distance were built later.

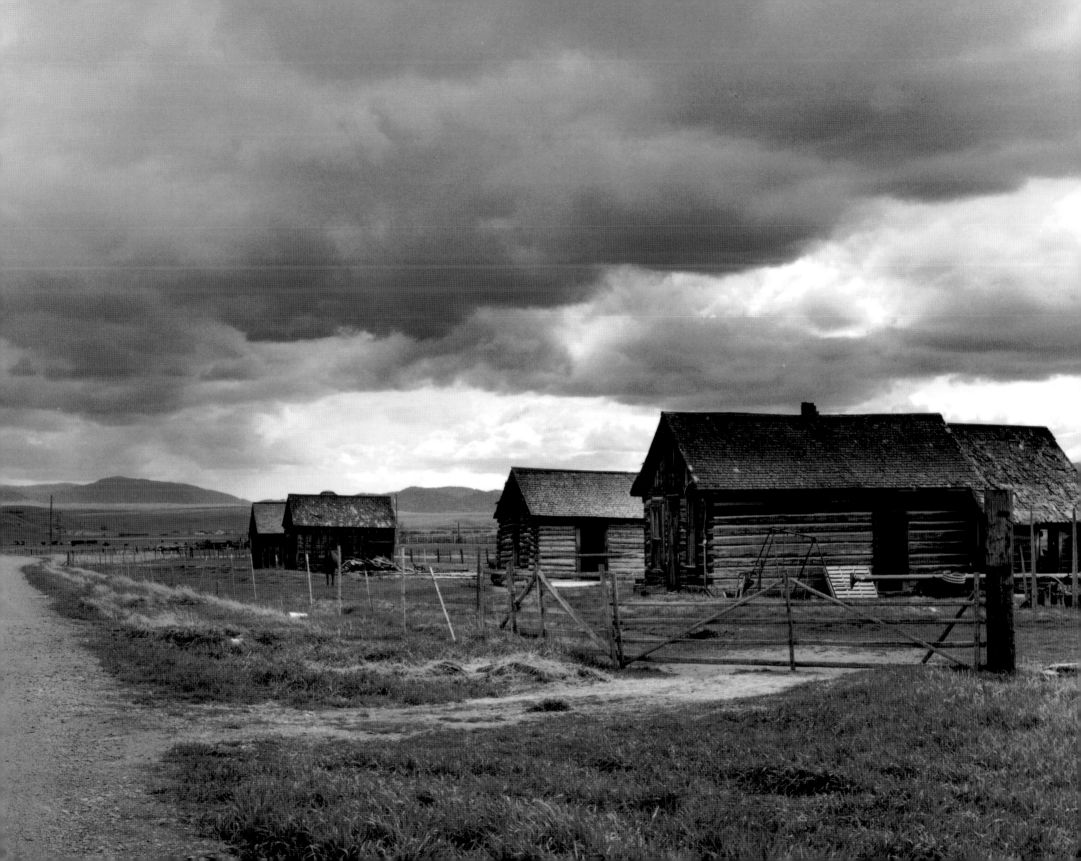

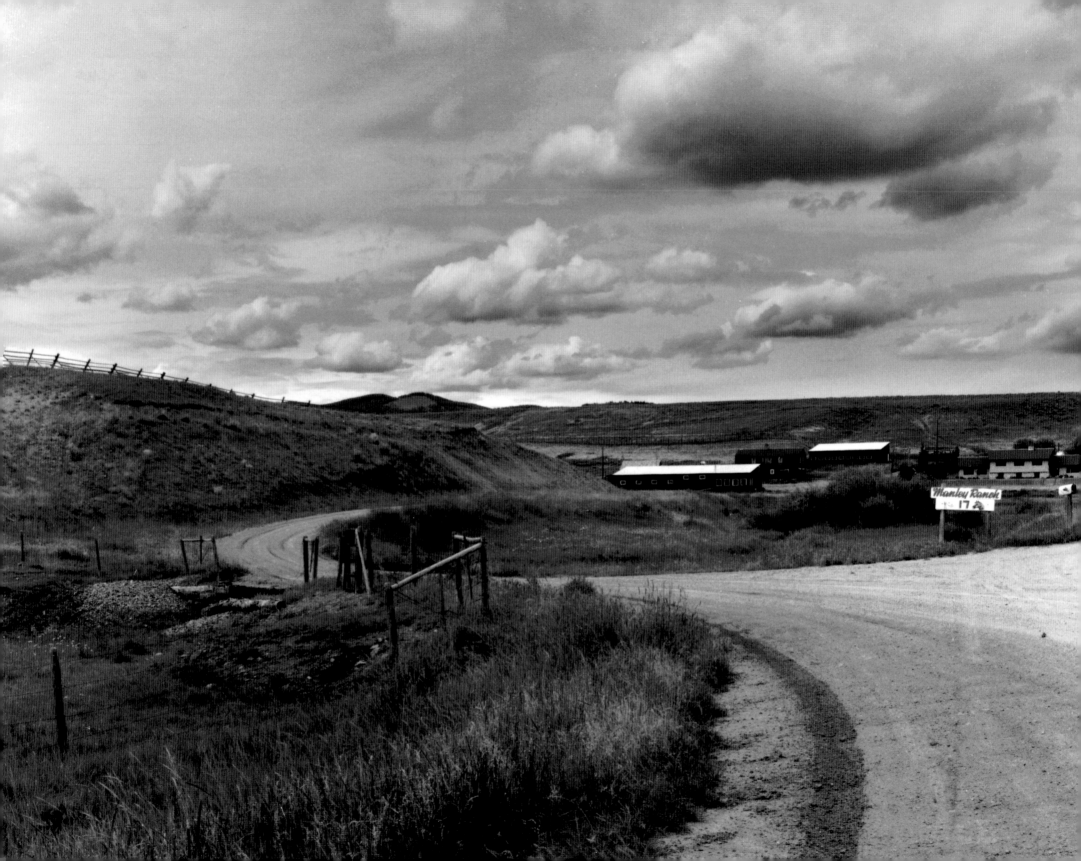

The Manley Ranch

To get to the Manley Ranch from Drummond, you head east from town on the service road and cross under the highway onto Montana Route 217. After about a mile you begin to head up a narrow winding canyon on a dirt road that feels like it would be impassable in bad weather, especially going downhill. However, this is the only road that runs from several tiny ranching communities to the north and is traveled daily by school buses bringing kids from outlying ranches to the high school in Drummond, as well as by logging trucks and people just going from one place to another. After a few minutes of being enclosed in these steep walls, the road makes a gentle curve, and you can see open country. Another bend in the road, and the scene that opens before you takes your breath away. Instead of the brown and green rolling fields of the Flint Creek Valley, you are in high desert country. Sagebrush, cactus, and other desert plants grow in tufts between the wild hay. Odd rock formations and conical hillocks dot the landscape. To the north the perpetually snowcapped peaks of the Scapegoat Wilderness feel close enough to touch, although they are more than 50 miles away. You are in another world, and you are also on Jan Manley's ranch.

Manleys have been ranching here for well over one hundred years.

The original 11,000 acres were bought by Jan's husband's grandfather in 1883. After her husband, John, who was a state senator for twelve years, inherited the ranch from his mother, he acquired about 7,000 more acres. He died in 1985. Jan now runs these 18,000 acres with one of their sons, his wife, their son, two hired hands, and "lots of machinery." Her three other children do not ranch. By any standard, this is a nice spread. They have dug five reservoirs and installed an extensive irrigation system that allows them to produce hundreds of acres of alfalfa, which makes better winter feed than wild hay. Their maze of corrals is right on the road about three quarters of the way between the canyon mouth and their large, well-built ranch house. Jan always makes sure that overnight corral space and water are available for ranchers driving their cattle from high country summer pastures to winter pastures in the Flint Creek Valley.

The corrals have an interesting history. They were built by John, who had a bad back and couldn't ride horses. To keep others from riding in the corrals when he would have to walk, he installed lintels across all of the pairs of vertical poles, making it nearly impossible to sort cattle on horseback. Today those cross pieces are still there, and cattle are still sorted either on foot or with four-wheelers.

Five generations of Manleys have lived on this ranch. I was always treated equal when my husband was alive. The men, generally, on ranches, treat their women well. Who feeds the hired men? Who raises the next generation? Who tends the house? Who takes care of all the book work? Who helps when they're short handed? But since my husband's died, I have found out that women are very definitely not equal. When John was in the Senate, he didn't know how to vote on the ERA, and I didn't either. We thought that since we were equal partners, it was unnecessary, so we ended up not being for it. But now I understand why it was an issue. To have a woman in agriculture try and go and borrow money from a bank, for instance—impossible situation. You just can't do it. Even John Manley's widow couldn't do it. I was never treated poorly by men or by bankers or by business people, until I didn't have a husband. I had to learn to fight back, and now I don't take anything from anybody anymore. It made me more protective than I was about everything, and I understood even more why the most valuable thing that John Manley had was the right to own this land, and why he protected it very, very closely.

And I'm of the same thinking. I lived with him for thirty years, and no one tells me—especially a man—what I can do with my land. It's mine, and I'm smart enough to know how to preserve it, how to keep our creeks and meadows and things like that clean. Ranchers are probably the best environmentalists there are. Because if we weren't, we wouldn't be here. We don't have to have government telling us what to do and what not to do. So for environmentalists and people who want to tell us how to live our lives, there is no access across this ranch. That's the way it's been all along, and that's the way it's going to continue to be—as long as I'm alive, anyhow.

—JAN MANLEY, OWNER, MANLEY RANCH

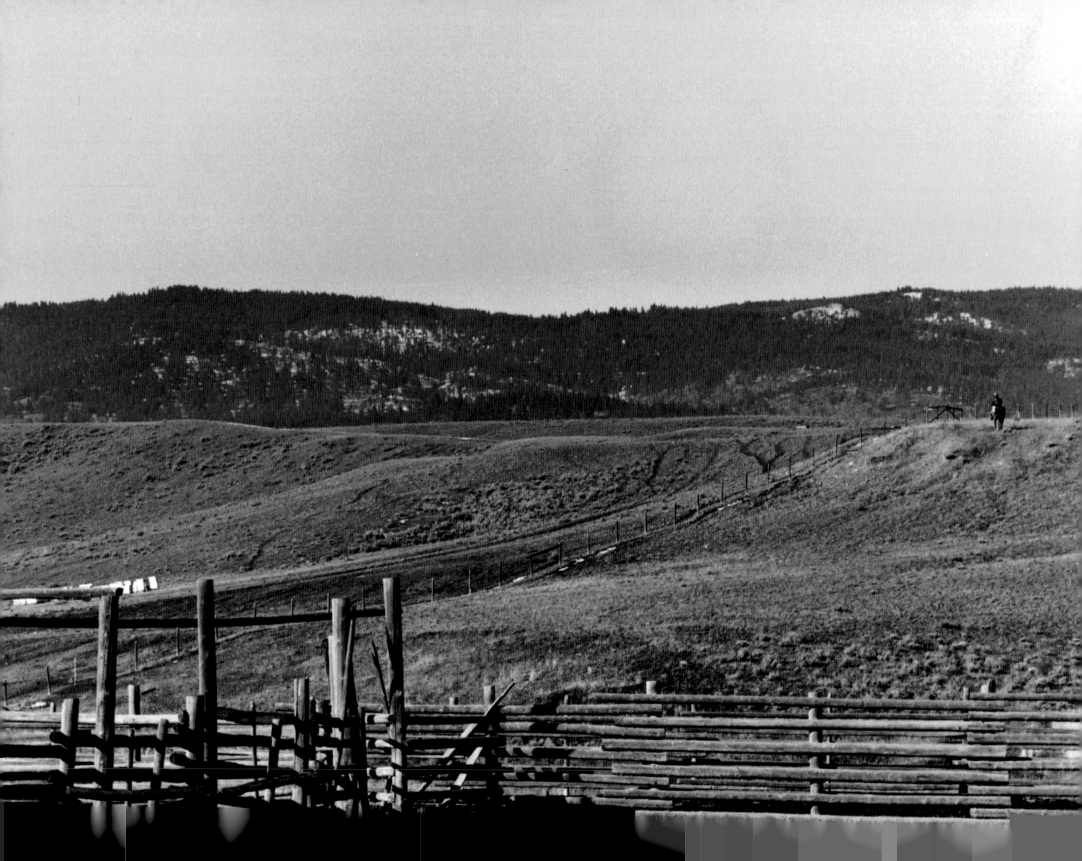

Facing page: Riding toward Jan Manley's corrals. Although Jan does not herd cattle into the corrals on horseback, ranchers will sometimes send their own cowboys to sales to help gather and load the cattle. Jan thinks that these horseback roundups are old-fashioned, but she understands the nostalgic longing to keep the past alive.

Right: Cowboys from eastern Montana bring their owner's new cattle through Manley's covered corrals to waiting trucks.

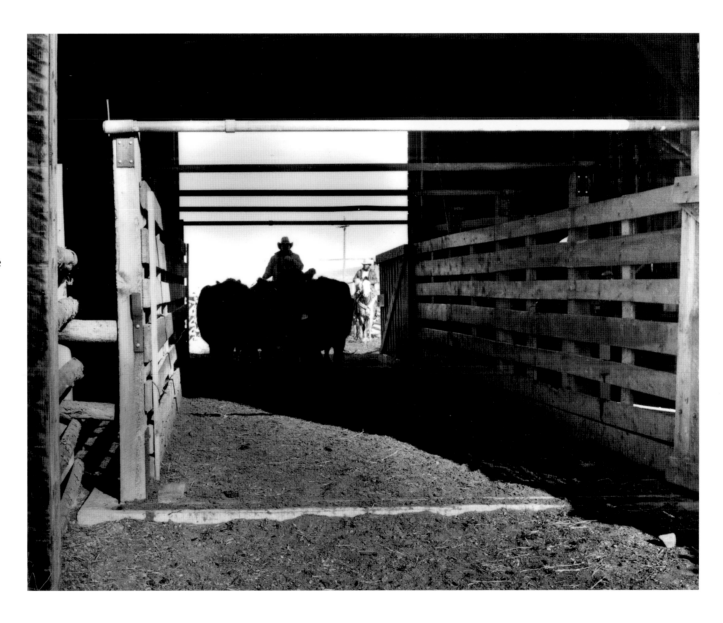

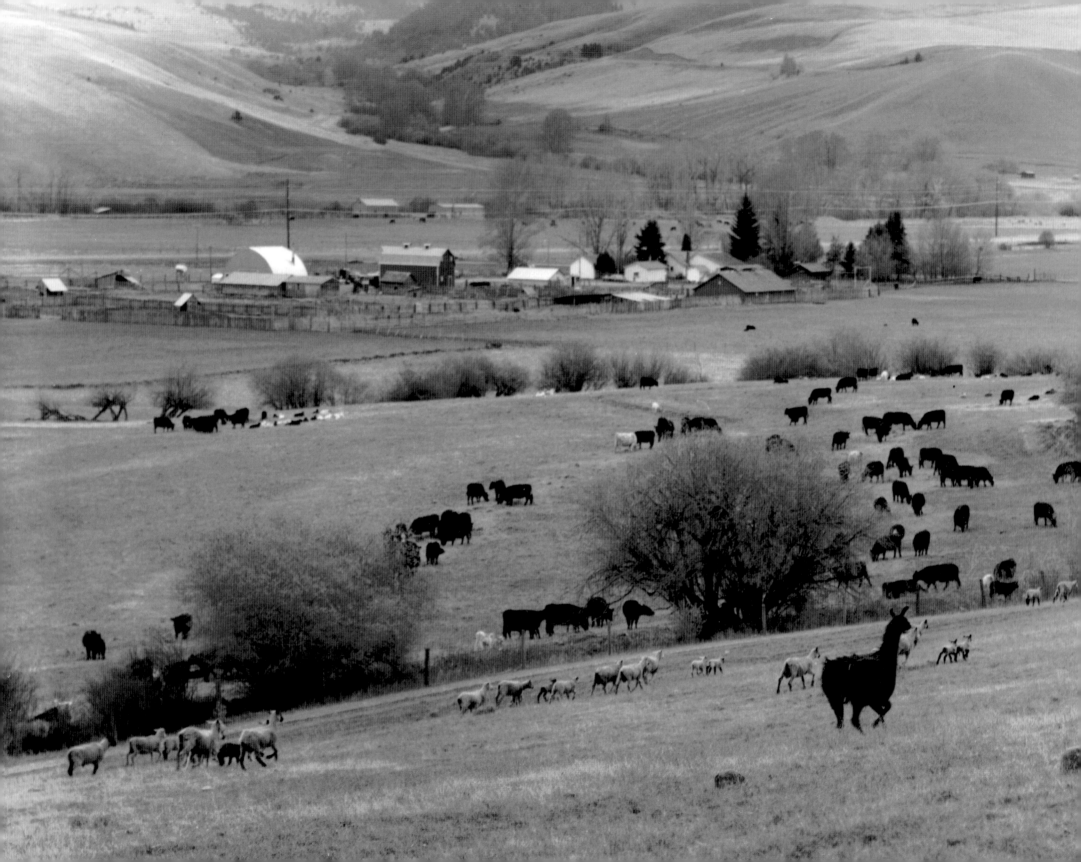

Mary Jensen

Mary Jensen's father, Alec Wight, was born in Ohio in 1842. He came to Montana in a wagon train in 1862, homesteading his place in the southern end of the valley in 1869 in an area called Stone (because of the many stones and boulders littering the fields). His wife, Catherine Hager, came to America from Germany as a child with her widowed mother and her five brothers and sisters. Catherine's father had died of smallpox as he was returning from the California Gold Rush to retrieve his family.

Catherine and Alec met when he was forty-eight and she was twenty-five. They raised sheep, had seven children, three of whom died in childhood, and grew prosperous enough so that Alec, a generous man by nature, was able to purchase ranches for each of his surviving children. His descendants now own much of the land in the southern portion of the valley, each generation providing for their children as Alec did for his. The home ranch is owned by his great-grandson.

Mary was born on January 14, 1902. She attended the local one-room school through eighth grade and then went on to high school in Philips-

burg, 25 miles to the south, where she worked in exchange for room and board. After high school she took a Normal training course to obtain her teaching certificate, taught in several schools, and spent some time with her mother's family in Iowa. She came back to the area in 1925 to teach school in New Chicago, where she fell in love with Emery Jensen, a local miner, whom she married in 1926. She and Emery had had only a passing acquaintance during their childhoods, because they had lived 10 miles apart and had gone to different schools.

In January 1927 they began ranching on the ranch her father had given them, which is across the road from her present house. They raised sheep and registered Herefords, struggling in their youth but doing well enough to follow her father's example and secure ranch land next to their own place for their daughter, Lois, and her husband Stuart Hauptman. Up until three years ago, Lois's daughter and her husband, Tom Linfield—the local veterinarian—and their children lived in a house they built next to Mary's. Mary's son Wight still lives at home and ranches registered Herefords with his mother.

Facing page: The Jensen Ranch, which is owned by Stuart Hauptman and his son Dan, runs sheep as well as cattle, one of the few ranches in the valley to do so. Mary's ranch, two buildings of which can be seen in the distance, is across the road.

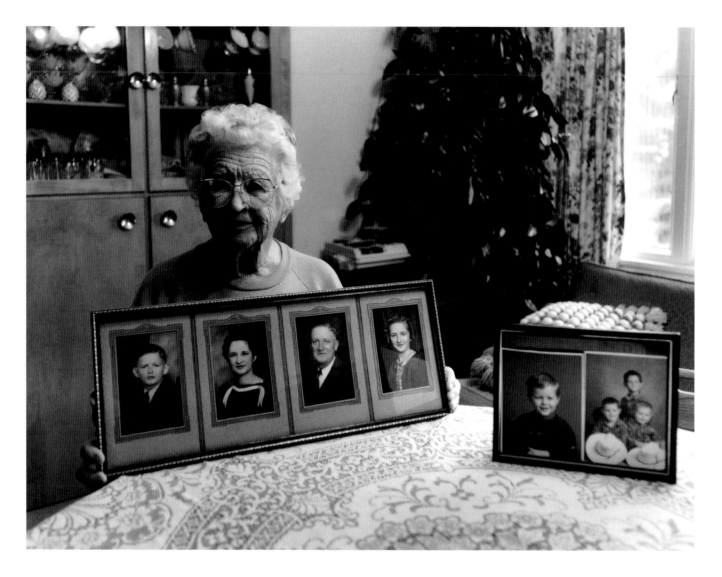

Mary Jensen holds photographs of herself, her late husband, Emery, and her two children Wight and Lois. Lois died in the fall of 1995. The smaller photos to the right are of Lois's son Dan when he was a boy, and Dan's brother Dave's three sons (Mary's great-grandsons).

was born in 1902, about 2 miles from here where I still live. In 1926 I married Emery Jensen. My father was against the marriage, because nobody was quite good enough for me, and he said he'd never give his consent. But when you're twenty-four years old, I guess you do it anyway, which I did. In January 1927 my father let us come down and live on this ranch, which we were delighted to do. We started out with six cows and a team. It was tough in those years. But we were happy and contented. We had our first baby, Lois, in September the following year. After my father passed away, we got a few more cows and a few sheep, and we just kept struggling along. And then our second child, Wight, was born in February 1930. When he was seven he developed epilepsy. He still ranches here with me. After Emery passed away, Wight needed help, so I drove the truck for him and also started vaccinating the calves. But now I see so poorly, that I can't drive the truck. Last spring I could still drive the four-wheeler. But I can only do what I know well, and I hope I can see well enough to help next year.

When we were young we used to go to the dances in Drummond. They used to call it the old Dreamland Theatre. They had a three-piece orchestra, usually, and you'd go and dance from 9 o'clock until maybe 4 or 5 o'clock in the morning. That was great fun. The railroad tracks ran right in front of our ranch, and I remember sometimes when we wanted to go to those dances, we had no way to go, and we'd go down in a handcar. Those were the days when we had programs, and you'd have five or six dances ahead and you could just be real important. And the young men were such gentlemen it seemed like in those days. No drinking or no carousing around. I remember at the dances there was supper at midnight. Your boyfriend would ask you to dance a supper dance, and he'd buy two plates for a dollar, and we'd all eat and then we'd dance again until 4 o'clock in the morning. And then we'd come back home in the handcar. Those were great old dances.

—MARY JENSEN

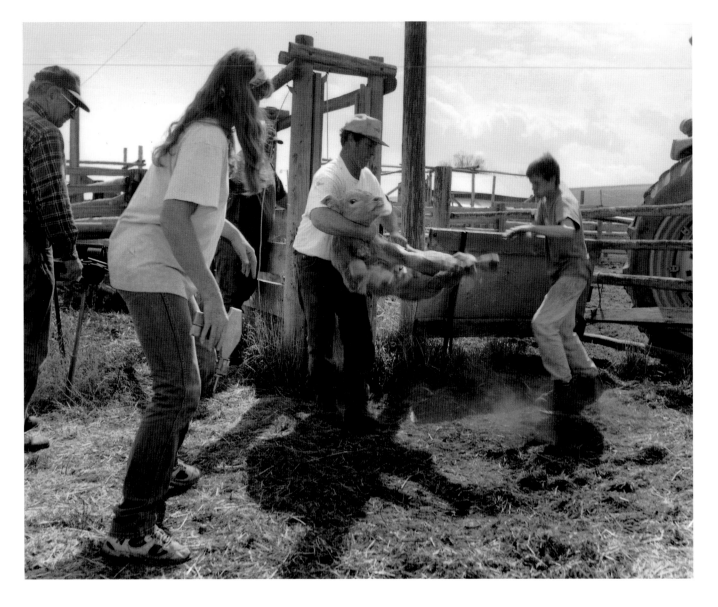

Dan Hauptman, in the white base-ball cap, runs his cattle through wooden chutes, grabs them as the chute door opens, puts them on the ground, and then his crew gathers around to brand and inoculate. While this may seem time consuming, Dan can get as many calves done in a day as those who flat bed or rope.

Wight Jensen, Dan's great uncle, calms the calves in the chutes as they wait their turn. T. J. Sheets, right, son of ranch hands Teresa and Tim Sheets, is typical of most ranch kids who help their parents when the school day is done.

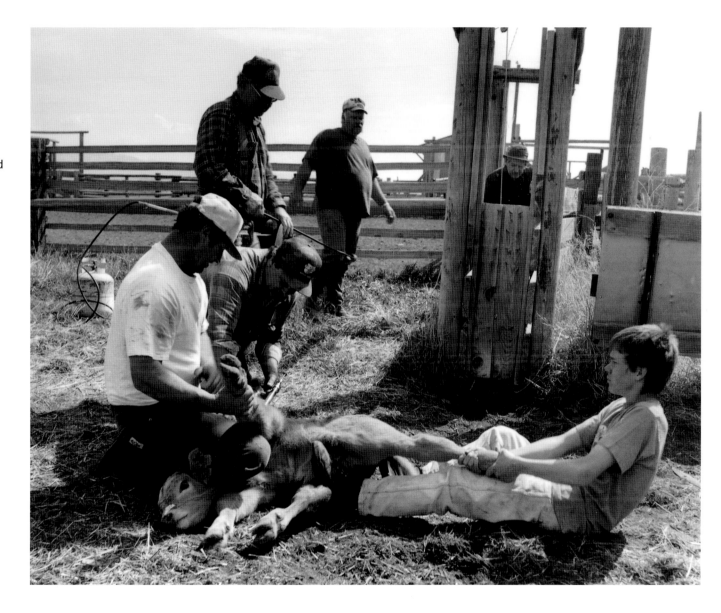

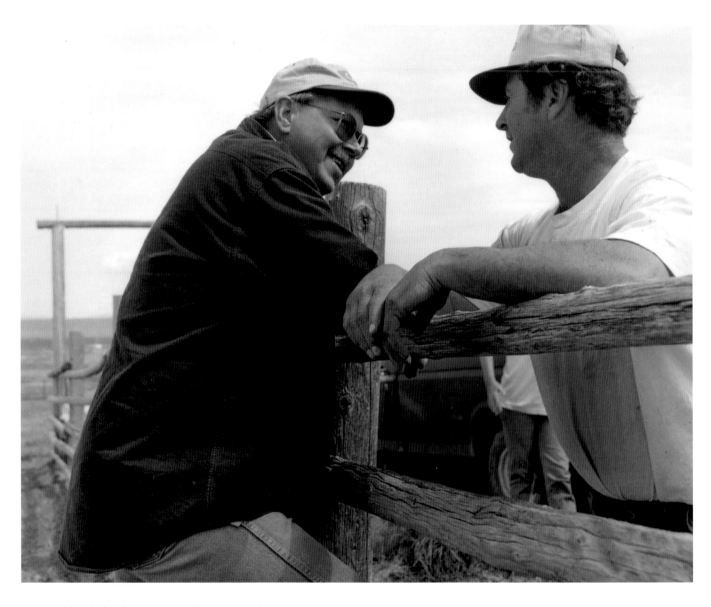

Dan and Butch Friede chat about the day's work.

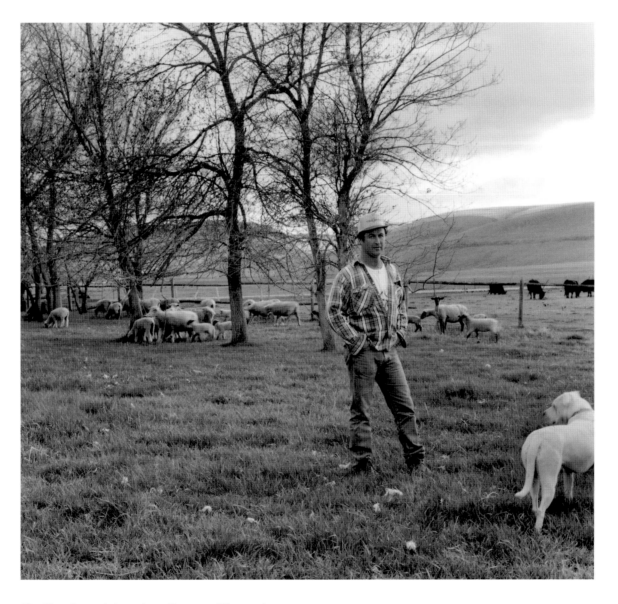

The Hauptmans' sheep have the run of the ranch.

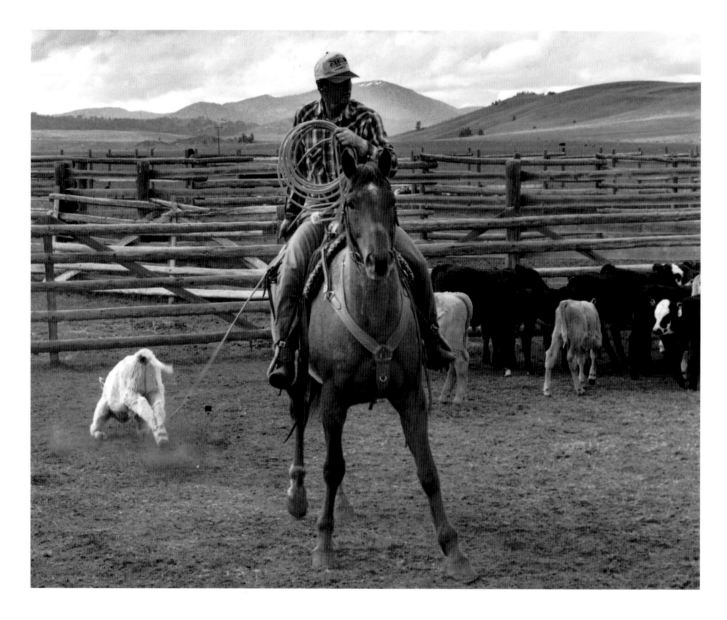

Left: Dan's brother, Dave, manages the Swiss Ranch in Hall. His horseback roping and branding days often attract people from hundreds of miles away. Depending on the number of calves, his setup can handle up to three or four being branded and inoculated at one time. This day they were not working many calves, the help was local, and they only did two calves at once.

Facing page: Larry Pralle and Randy Peterson wait for the calves to be let into the roping corral.

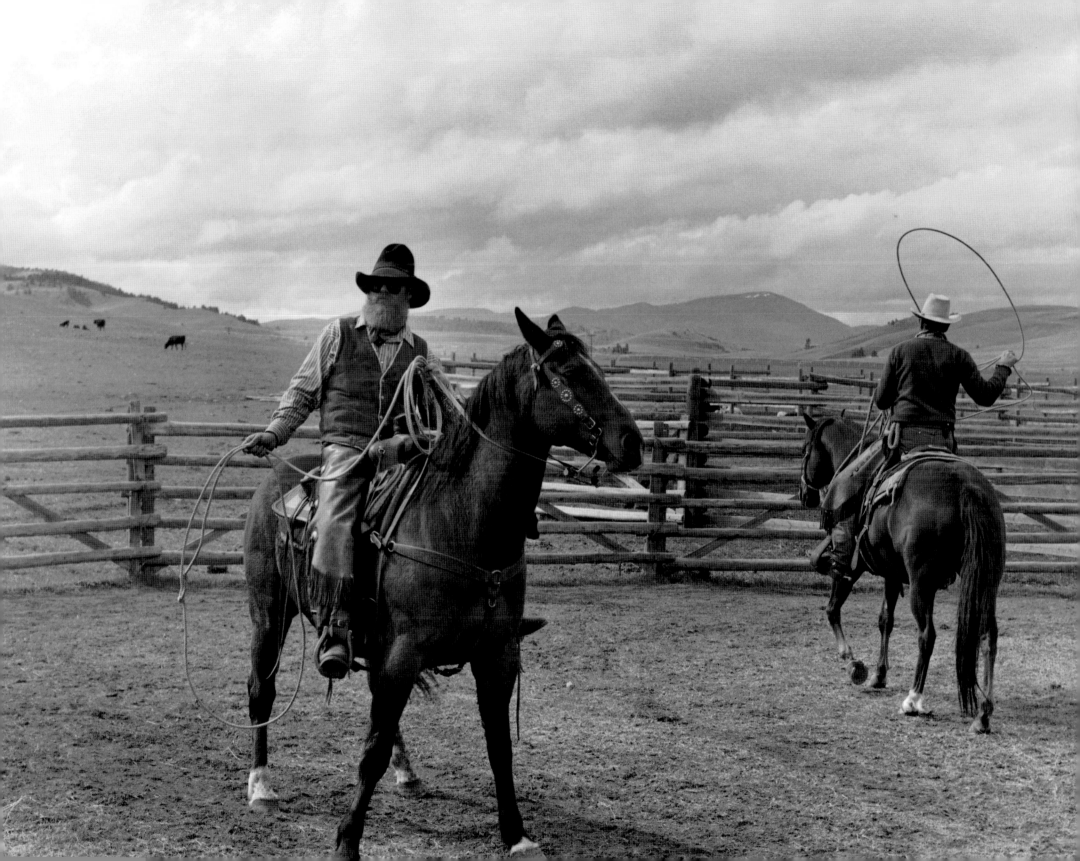

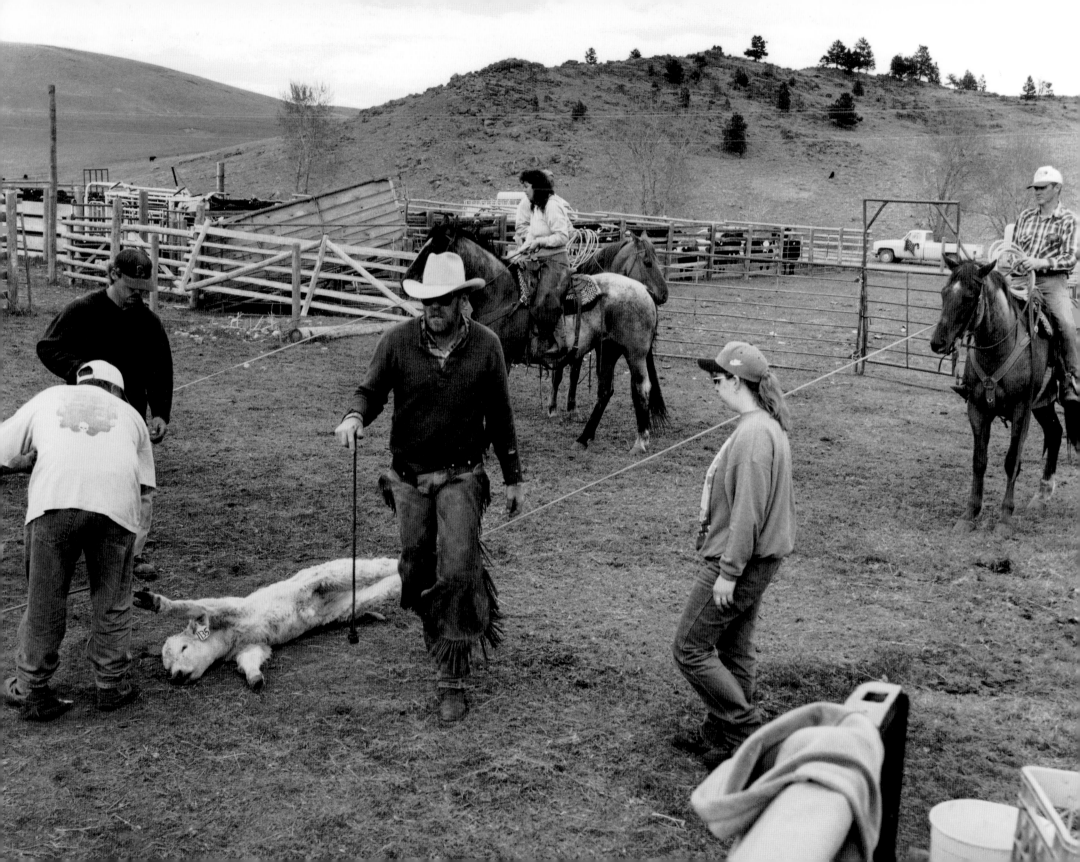

Facing page: Randy takes his turn at branding, working the calf that Dave has roped. Susan Ostler is the other rider with a roped calf waiting.

Right: Susan and her husband, Dave Ostler, in the roping corral

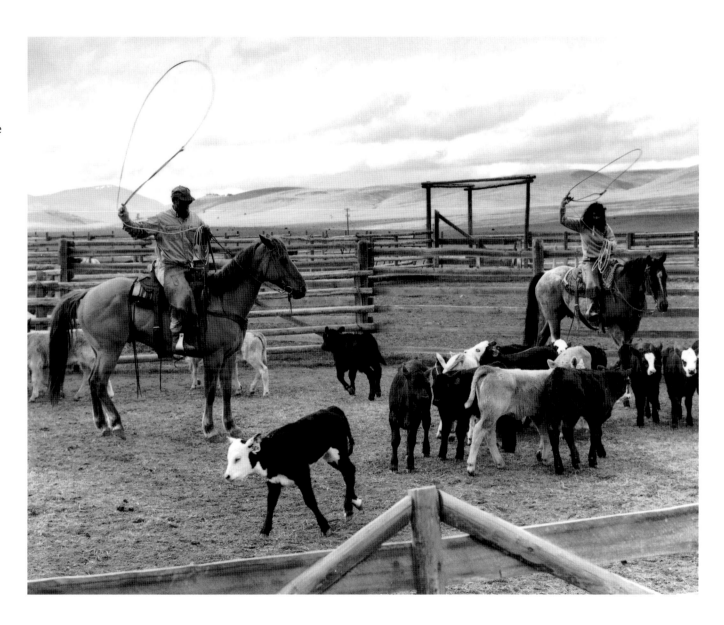

Calf branded with the Swiss Ranch brand—Bar T Lazy S

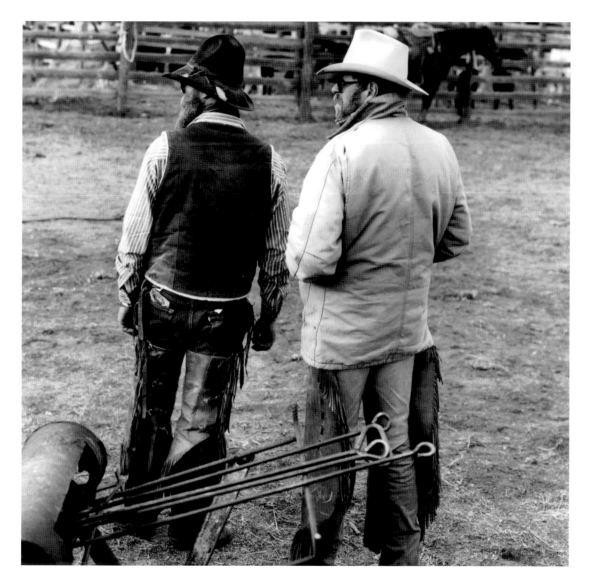

Larry and Randy waiting to brand

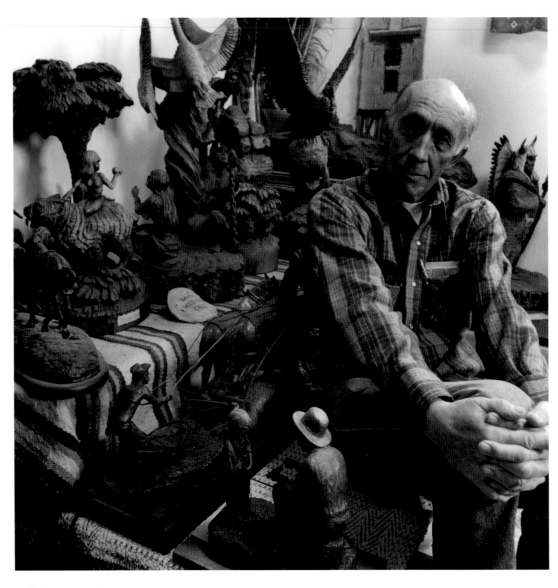

Bill Ohrmann in his storeroom

The Ohrmann's

When you drive up to Bill and Phyllis Ohrmann's ranch, you'll see a welcome sign in the shape of an artist's palette, with large dabs of colored paint in rainbow order. Bill raises registered (purebred) Angus bulls. He is also a professional artist, a rare combination. He is able to do both successfully partly due to his own talents, and partly because it takes fewer cattle, less land, and therefore less time and energy to make a living from registered bulls. As a matter of fact, a smart rancher can make the same living from 50 to 60 registered bulls as he can from running 300 commercial cattle, because a well-bred, well-raised bull brings in about five times as much per head as a beef steer.

Bill's son, John, who is also an artist, has ranched with his father since 1979, when he returned from Montana State University in Bozeman with a master's degree in engineering. John rented a place adjacent to his father's, acquired his own small mixed herd of registered and commercial cattle, and followed his dad into the bull business. In the fall of 1995, he decided that he wanted to free up more time for his art work, so he sold off most of his own cattle and now works with his father three days a week.

Sue Peterson is Bill's daughter. She and her husband, Randy, also raise registered Angus bulls. Their ranch has deeded water rights dating from 1868, making it one of the oldest ranches in the valley. Onita Nelson's parents, Henry and Ella Kolbeck, were the original owners, and Onita grew up on that ranch. The Kolbecks then passed the place to their sons Evan and Art, and their daughter-in-law, Dora. The Petersons purchased it from them in 1990.

'm a rancher. I was born in Philipsburg and grew up in Ovando. My parents bought this place when I started in high school. So I've lived in this house since 1934. I make my living ranching. But I always drew. Mostly cartoons. I never was a great painter. I always did whittle, carve things, even in grade school. I just picked it up on my own, not in school. It's really play for me, and I've always done it. But I have sold a lot of my work over the years.

People like to see traditional western art, like my Charlie Russell, here, and I do that. But I just like to make things that are different, that have never ever been done in the world. For instance, Little Eve, riding on the tiger. I've made her when she was a teenager and just practicing. I know those things have never been done in the world.

—BILL OHRMANN, RANCHER AND ARTIST

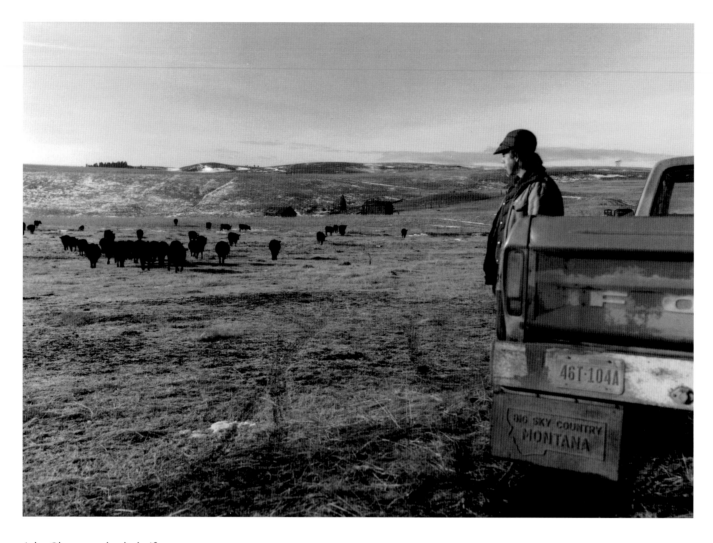

John Ohrmann checks heifers.

Phyllis Ohrmann walks the "girlies" to their calving area.

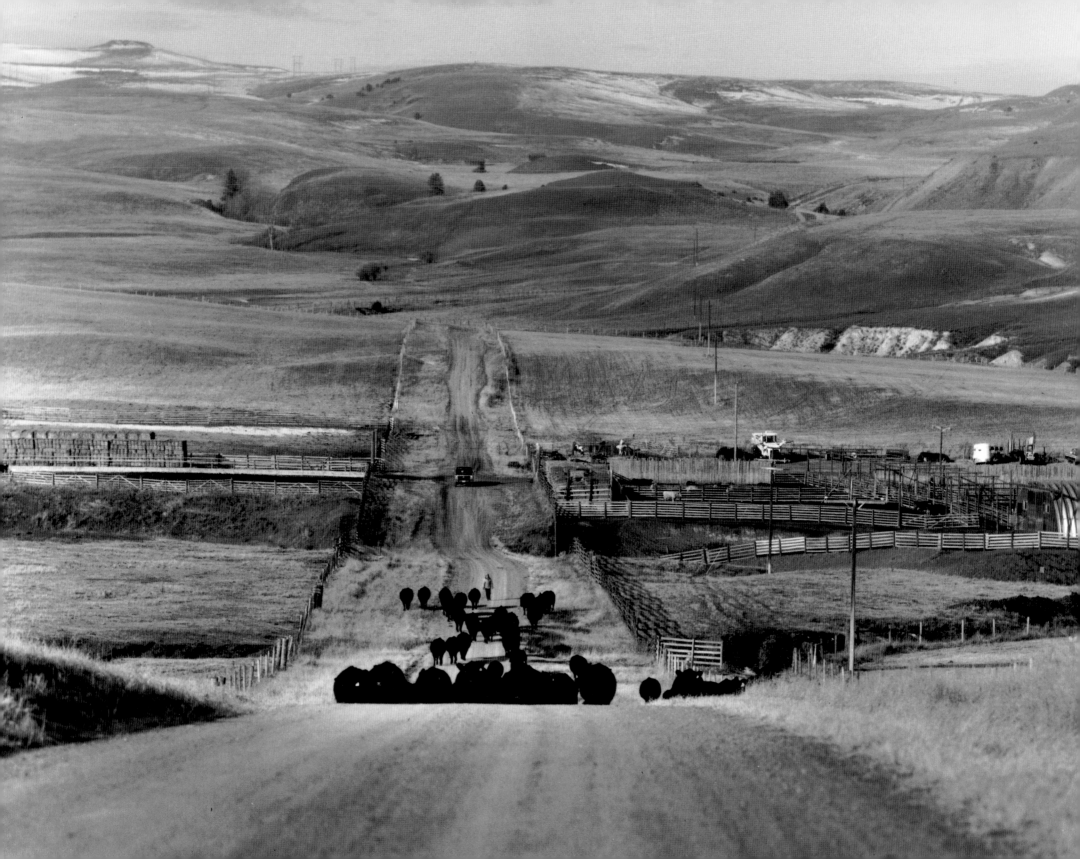

Facing page: Driving the "girlies" home

Right: Bill (left) and John in their calving corral

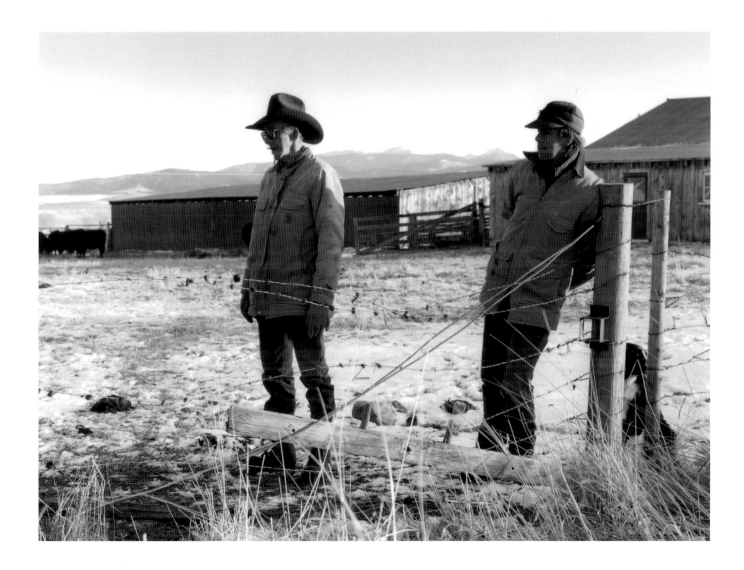

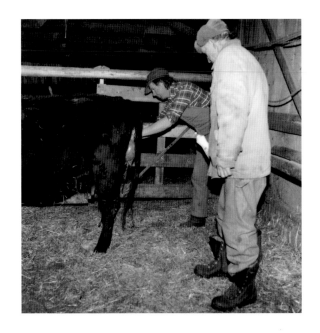 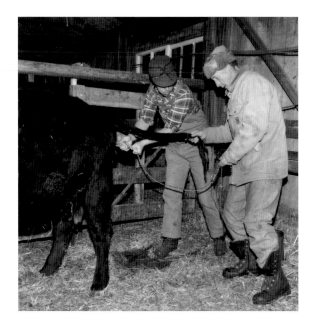 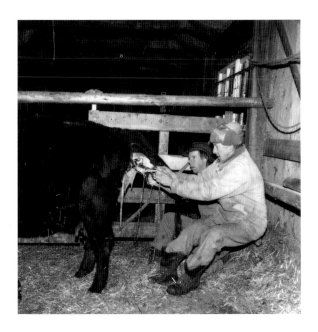

When the feet look about a certain size, well, then we know we might have trouble. And if the heifer doesn't make any headway for about a half hour, well then you know that she's in trouble. That's when we get out the obstetrical chains. We slip the chains on the feet, beyond the hoof, so it doesn't work on that joint, and pull one leg, and then the other, and kind of alternate that way until you pull the calf out. We do it by hand rather than use a

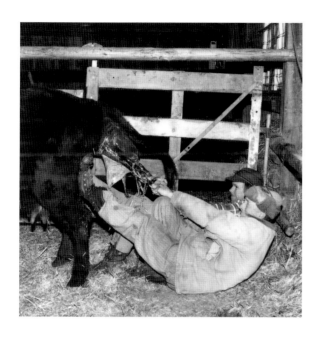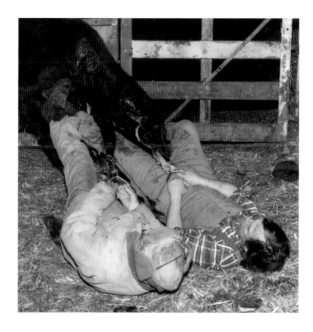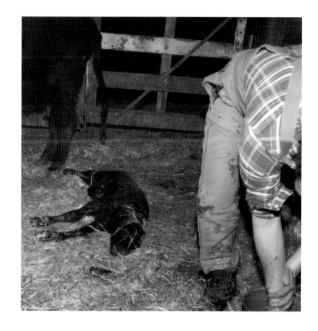

puller, which really is kind of hard on us. But Dr. Metcalf told me that two people can pull about has hard as you should pull on a calf. So he thought pulling by hand was actually the best way. This one had a rough journey out and was pretty exhausted. But the mother claimed it and was talking to it. It looks dead here, but in less than an hour it was on its feet and doing okay.

—BILL ORHMANN (IN LIGHT-COLORED BARN COAT) AND HIS SON, JOHN

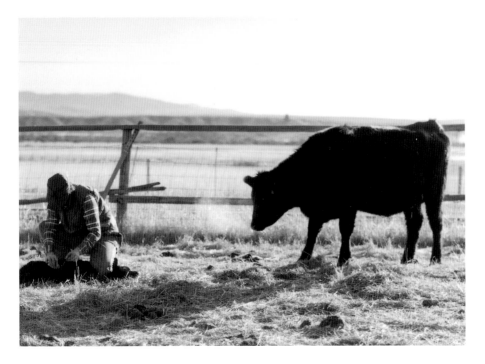
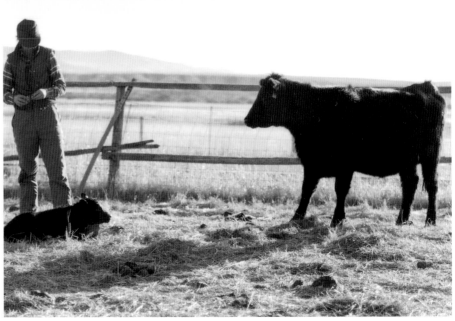

E ven though mama isn't sure she trusts me, weighing and tagging in a winter like this, where it never goes below zero, is a breeze. In 1989, during the big blizzard, we had full-grown cows whose ears and tails froze right off, it was so cold. But on mornings like this, things like that seem far away.

—JOHN OHRMANN, JANUARY 1994

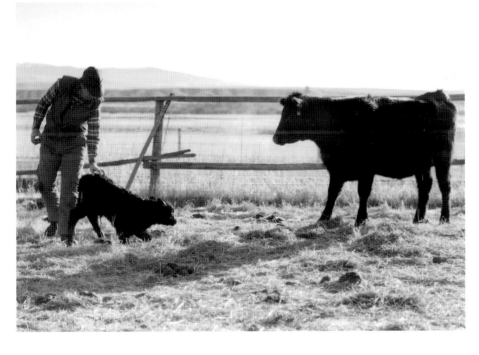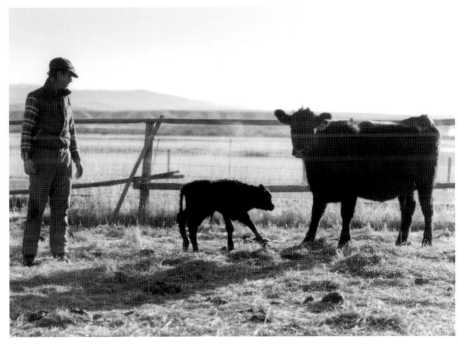

Facing page: Looking across from the Ohrmann's ranch toward New Chicago

Right: John Ohrmann, early winter morning

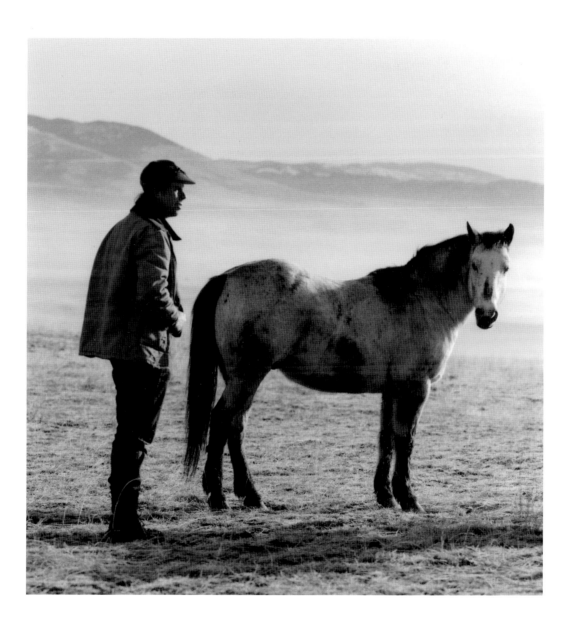

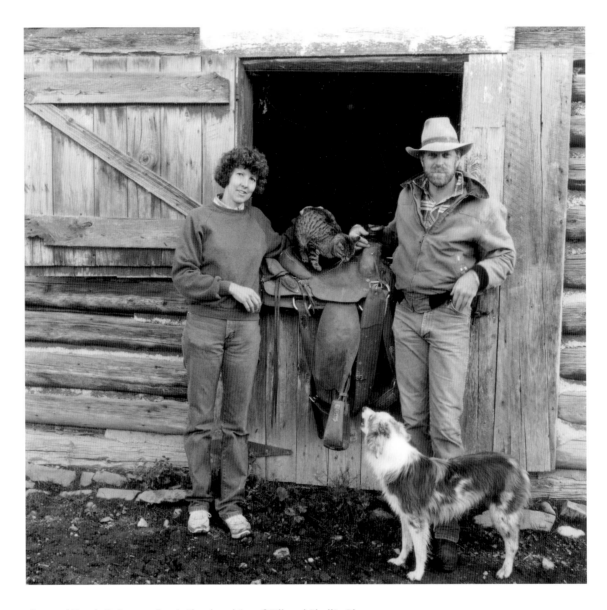

Sue and Randy Peterson. Sue is the daughter of Bill and Phyllis Ohrmann.

t's so hard to get a place of your own when you don't have anything to start out with. It's something that we really wanted, though, and even though I have to teach to make it work, it's worth it. I think that people who have to work to get a ranch feel differently than people who inherit it. We were real lucky to get this ranch when we did. Now we wouldn't be able to afford it. Some of the buildings are over one hundred years old and full of history. We have 420 acres down here, and there's a forest permit up on Douglas Creek that goes with the place. We have eighty to one hundred cows, and some bull calves, and we're real proud of the quality of our cows.

—SUE PETERSON

think we have really good cattle, I must say. But I think that the only reason I have cows is so that I can have horses. I love horses. And I love to ride. And when I have time, I build saddles. I learned from this old saddle maker, Bob Stewart, at the prison in Deer Lodge where I used to work. He'd been in and out of there since time began. This one that Sue rides was the first saddle I ever built. This year, though, I might have had time to make another, if I had known it was going to be too cold and wet to hay. I guess this weather's just a reminder that Mother Nature is still the boss. It humbles you and reminds you that ranching isn't a way to get rich. You're lucky just to make the payments. It's a way of life, though, that gives me the chance to be outdoors.

—RANDY PETERSON

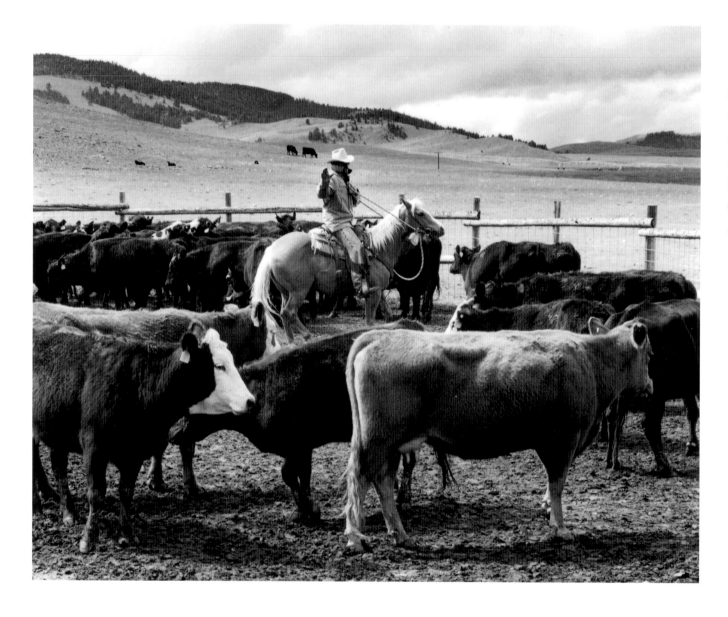

Randy is an expert horseman who uses a minimum of sound and motion and a maximum of gentleness when he works with animals. Here he uses a slowly raised hand to guide cattle into the inoculation chutes.

Abandoned homestead just beyond
the north end of Bill Ohrmann's
hayfields

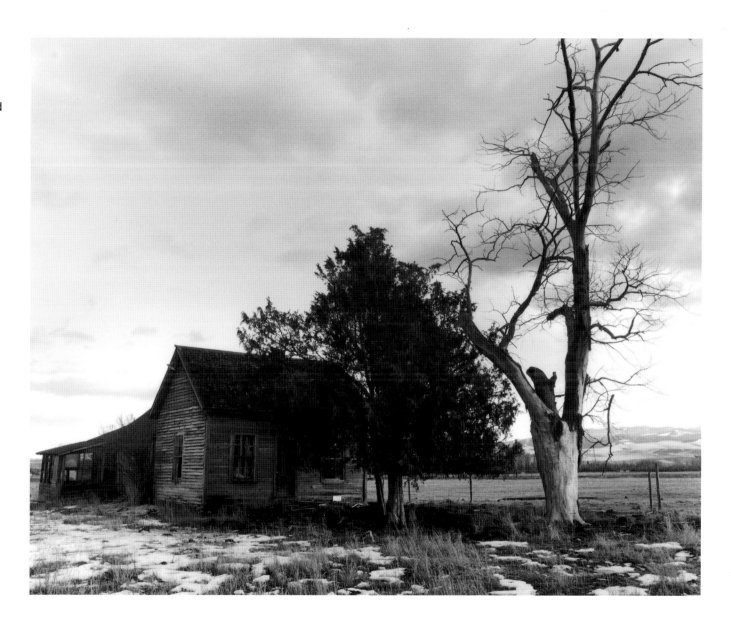

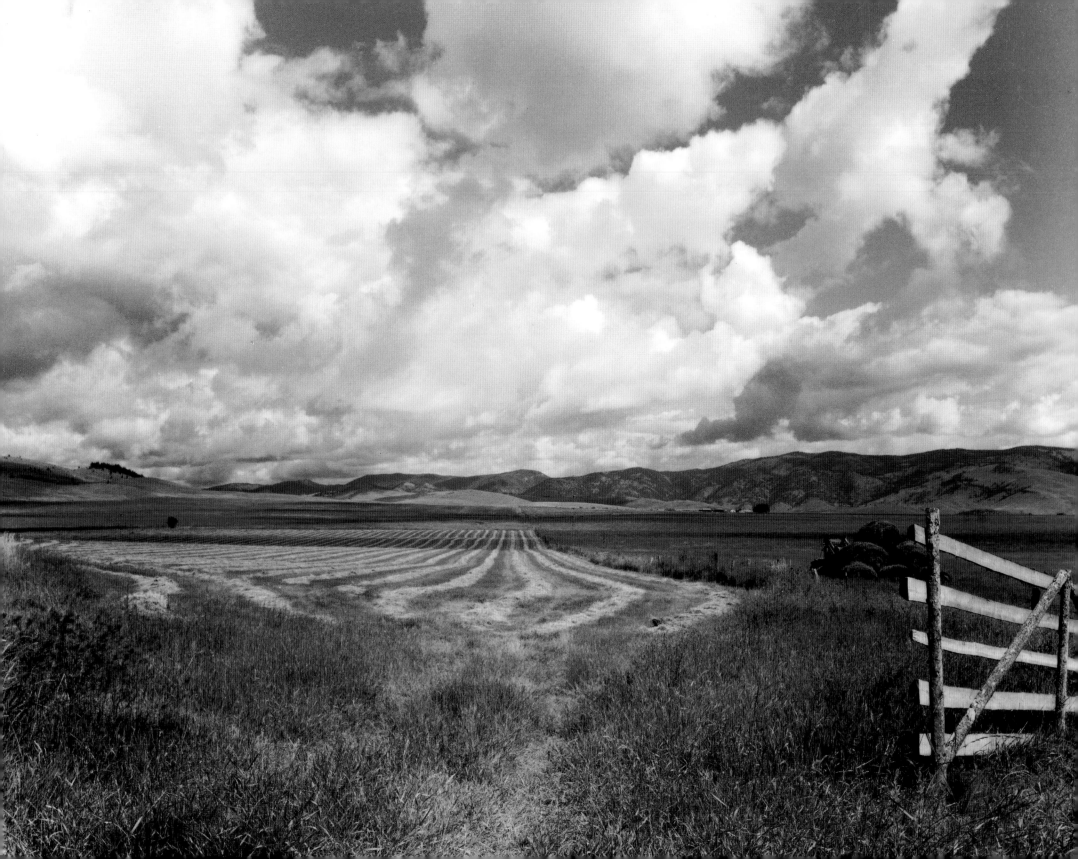

The Corlett Ranch

To get to the Corlett Ranch, you drive south out of Drummond to what is still called the Airport Road, despite the dismantling in 1994 of the tower that was the last vestige of that small airfield. Turn west and follow the road up the hill, through a wide plateau of fields and ranches. After a little over a mile, before you begin to climb the bare hills at the western end of the bench land, turn south for a half mile, and you come to the Corletts's two houses—Cy and Esther's on the right, and Cy Curtis and Chloe's on the left—snuggled close to each other at the edge of a hill overlooking the southern end of the valley.

Esther Corlett was born and raised on a farm in North Dakota. Cy Corlett was raised in the town of Drummond. His grandparents ran the old hotel, and his parents owned the meat market that had once belonged to Duncan Dingwall. When he and Esther married in 1944, they moved to the ranch that his father had acquired during the Depression in exchange for grocery debts. The place had been idle for nineteen years because there was no irrigation water on it. There were no buildings except for an old log cabin under the hill, no fences, and no well.

They moved a two-room cabin from west of Drummond, put in an outhouse under the hill (which was a long way to go in December), dug a well, and began to improve the place. In 1946 Cy brought out an old toi-let bowl from town, and they had a real bathroom—albeit an outdoors one—which made a significant improvement in their lives. They put up fences, built barns and corrals, and added to their two-room house. They purchased shares in a WPA irrigating company that brings water to several ranches in the area through a series of complex ditch systems from a dam 30 miles away. They worked the place pretty much by themselves until their only child, Cy Curtis, was old enough to help. Cy Curtis still lives on the ranch, next door to his parents, with his wife, Chloe, and their daughter Kelsey.

The Corletts are known and loved throughout the area for their music. Esther taught piano, both in the school in Hall and to private students, and she still plays organ and piano for recitals and at local churches on Sunday mornings. Cy, who died in 2001, sang in local churches and in a chorus in Missoula, the Mendelssohn Society, which travels throughout the world. Cy Curtis used to have a band that played local dances, and he still plays country and western guitar when he can. His daughter plays the clarinet. His wife, who teaches special education in addition to ranching full time in the summer, can't carry a tune.

The ranch is small by western standards. The original ranch was only a quarter section (160 acres) that has been added to over the years. Since

the Corletts raise valuable registered Angus bulls, they run a more concentrated operation and need less land and fewer animals to make a living. Theirs is the only ranch in the valley that uses beaver slides, rather than baling, to put up hay. A beaver slide is a haystacking device that was invented in the Big Hole Valley, about 100 miles to the south of Drummond. The stacks are called beaver piles.

When Esther came to Drummond to work at the airport, she asked if there was a service to take her trunk to where she was living. Well, she was told there wasn't, but Dee Corlett over at the store, who was my dad, had a pickup, and they were sure he would help her. Well they sent me out to haul that trunk, which I didn't want to do. So when I unloaded it, she said, "I'll buy you a beer for this some time." I got kind of teased about this beer I had coming from this woman, but by the following spring, we were married. We moved out here that Christmas, and we've been here ever since.

—CY CORLETT

One Saturday while I was teaching in Miles City, I was bored, so I took a Civil Service test and was accepted for an aircraft communicator. That's how I came to Drummond in 1943. All the training planes from Spokane came over here, so we had a lot of responsibility and the pay was good. There were only three of us rotating through the twenty-four-hour shifts, which meant you didn't get much time off or any vacations, and whatever had to be done, why, you did it. Except one time I was supposed to climb that tower to change the beacon light. Luckily someone else was around who said he'd do it. And one time we got a message that there may be Japanese coming over in balloons, and we were supposed to have an armed guard at the airport. Well, of course at Drummond, there was no such thing as an armed guard. So I used to carry scissors with me—in case any Japanese came, I could give them a little trouble.

A group of us got our pilot's licenses out here flying in a little Piper Cub. Working here, I could call all the people taking lessons and then call for the Cub, and it would come from Missoula and train us all. We had to watch out for gopher holes when we landed, and sometimes it was pretty muddy. There was one man— I probably shouldn't tell you this—but he was so heavy that he'd sprung the landing gear, and when they brought the plane back to Missoula, they asked what had happened to it. Finally they had to tell him he couldn't fly anymore.

—ESTHER CORLETT

Esther Corlett stands at the aban-
doned airfield. The tower and shed
were torn down in April 1994 to
make room for flood irrigation
ditches.

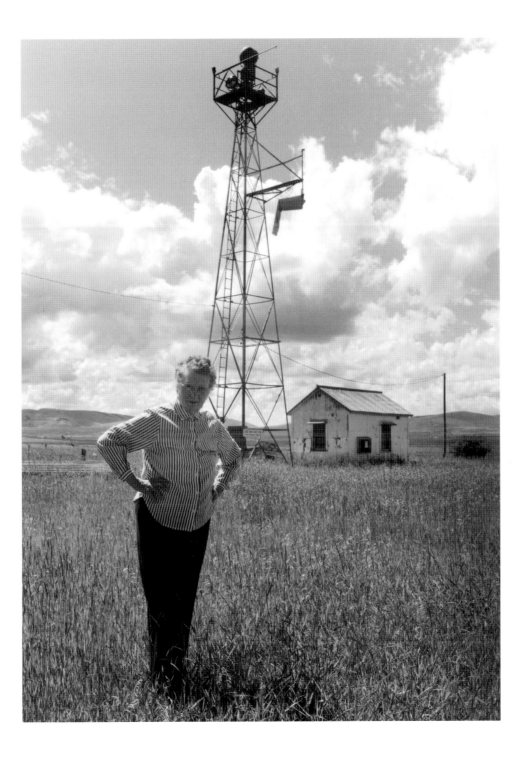

Left: Cy Curtis uses his tractor to scatter hay from his beaver stacks.

Facing page: Cy pitches hay to his champion Black Angus bulls.

Following pages: Straw for bedding cows during calving

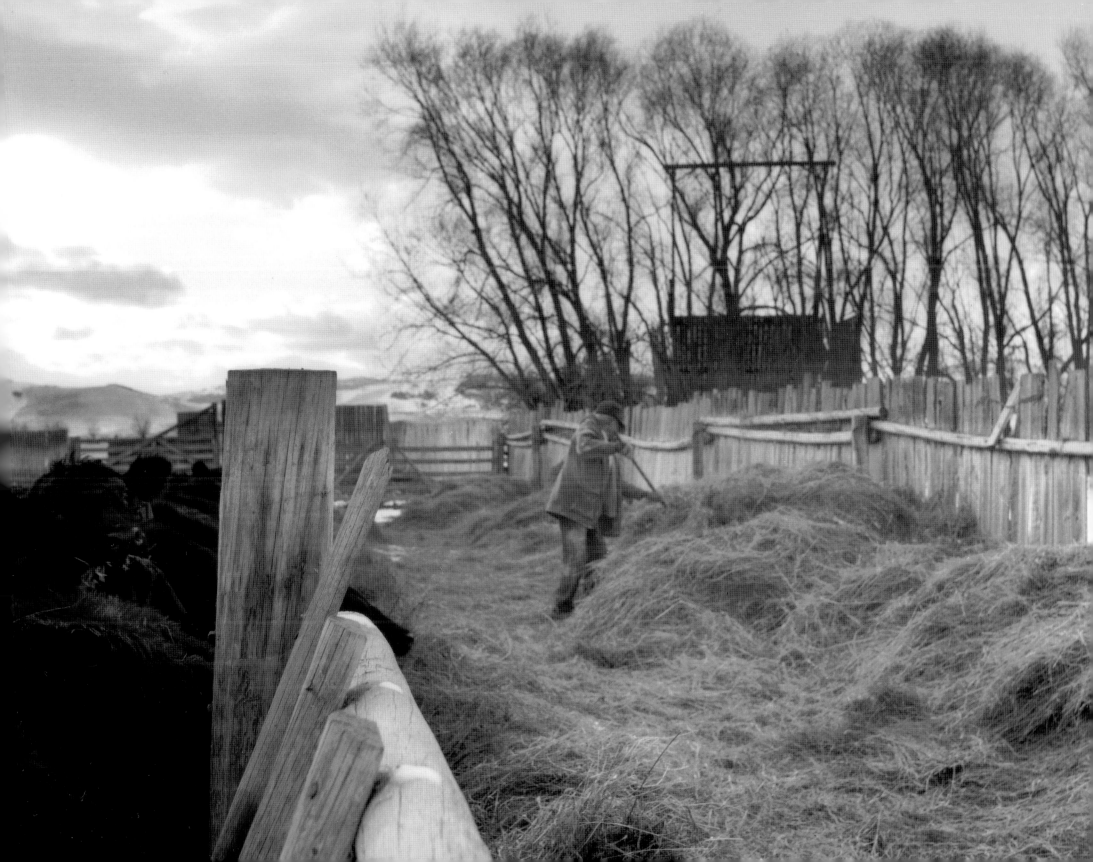

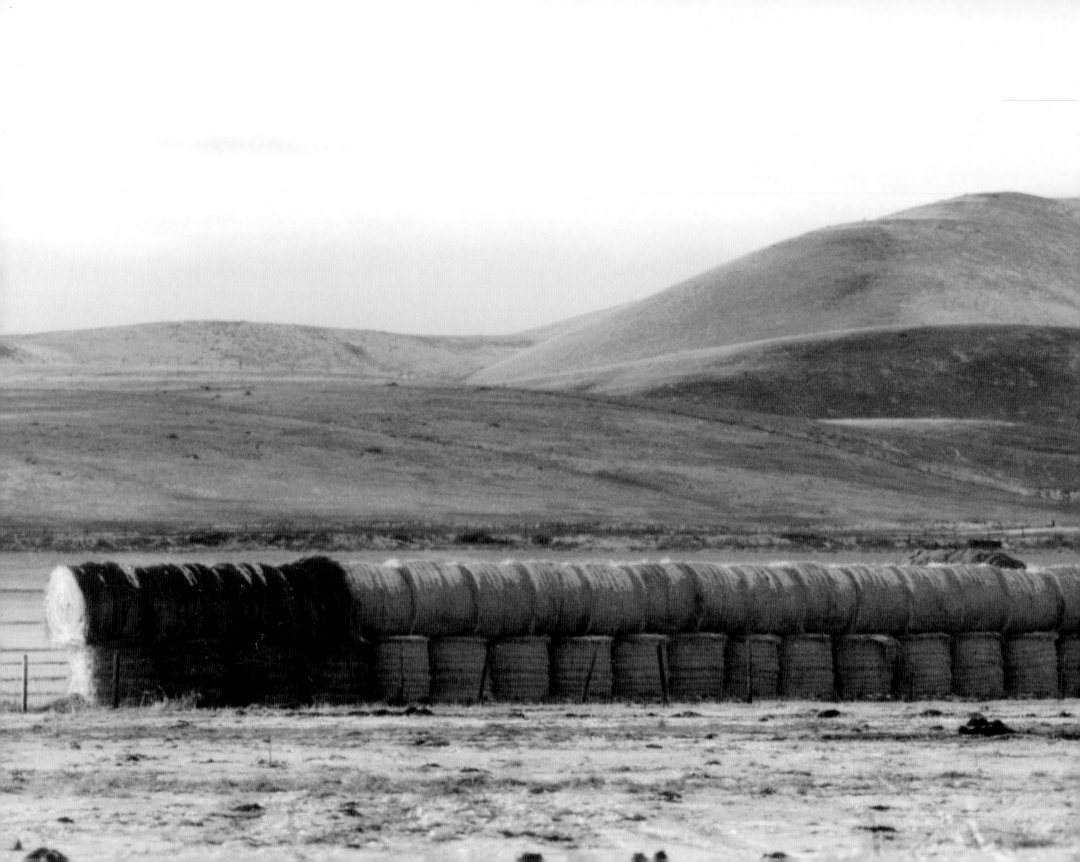

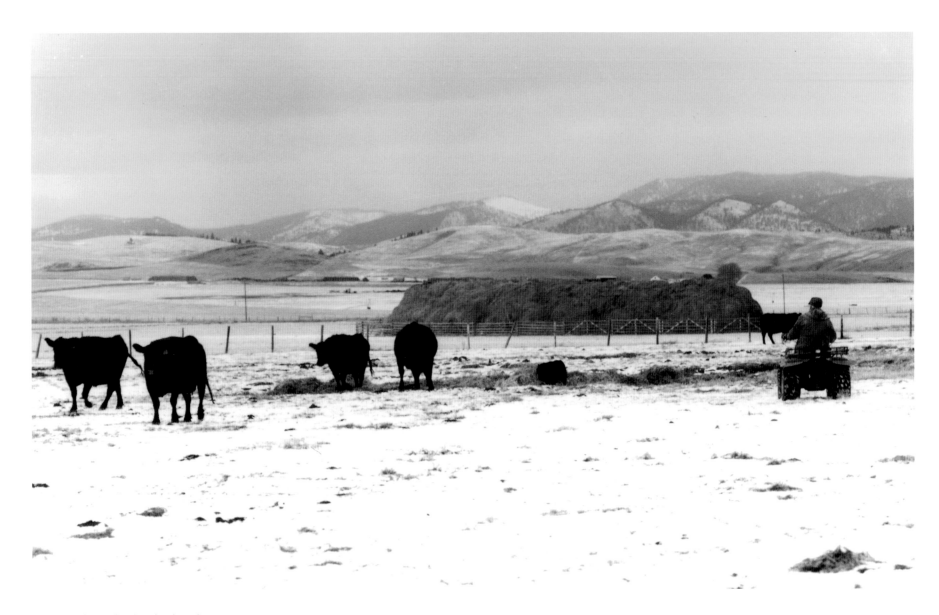

Cy on his four-wheeler checks calves.

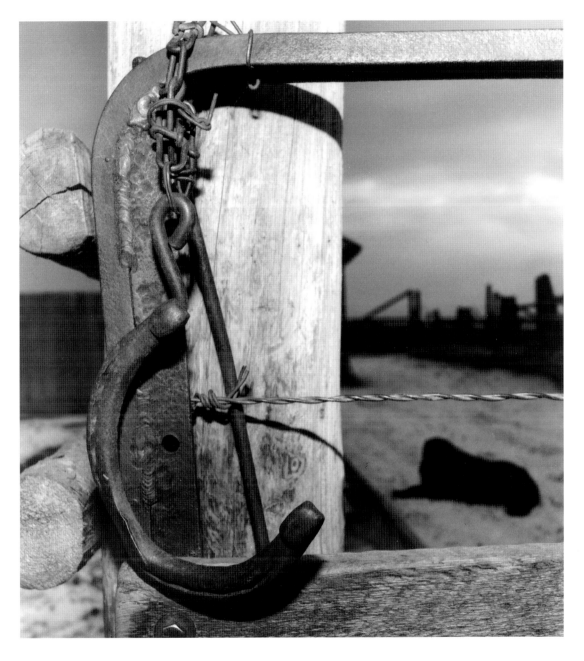

Horseshoe gate fastener

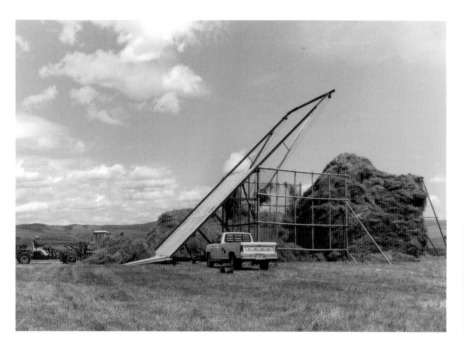 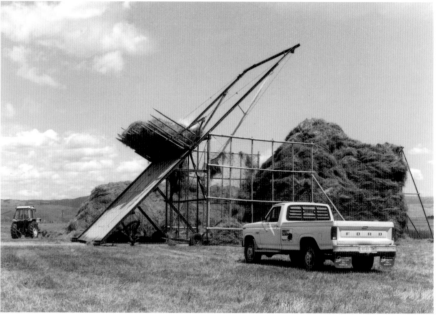

Buckrakes, driven by Chloe and Esther Corlett, gather the cut hay into manageable piles and then bring them over, one at a time, to the beaver slide for stacking. The hay is then loaded into a basket that is raised by a rope pulled by a pickup truck. These stacks are so dense that they are completely watertight.

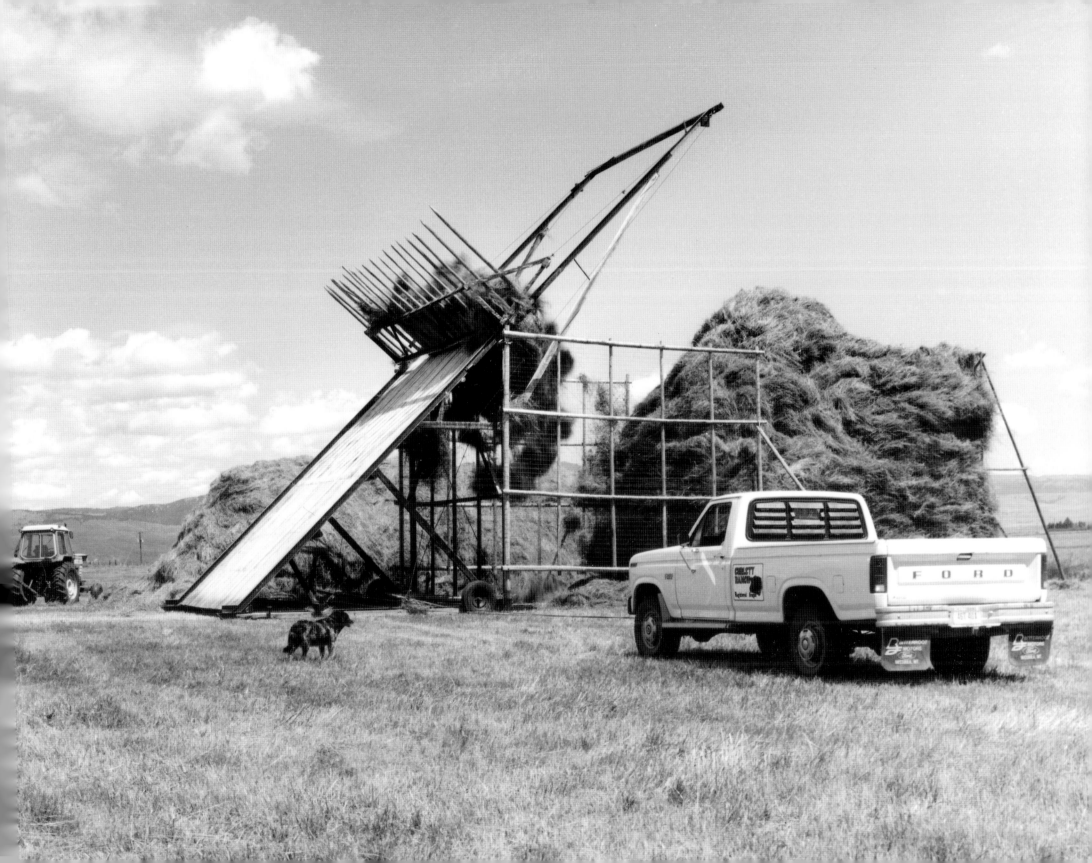

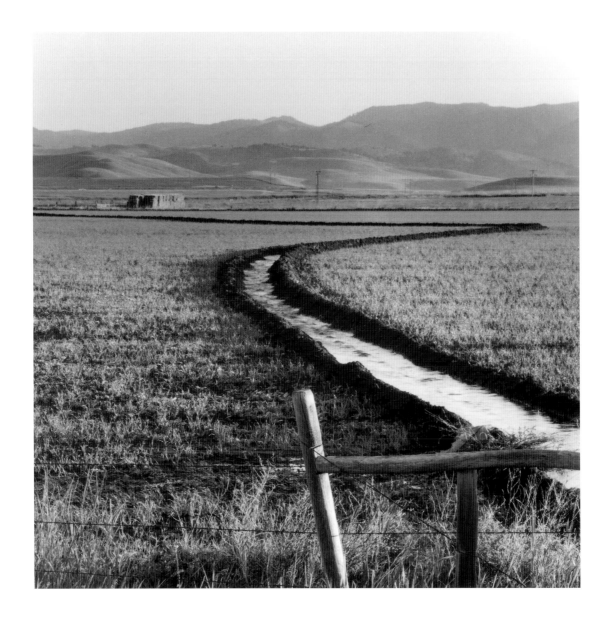

Lewis and Dorothy Hill

Lewis and Dorothy Hill live south of town on the Airport Road in the center of the same plateau as the Corlett Ranch. Lewis Hill was born and raised in Drummond (his father, John Hill, was the leader of the first Mormon settlers in 1915), but he was married and living in Pennsylvania when the ranch he lives on now came up for sale in 1951. For him, coming home was the opportunity he had hoped for. Even though the property was not well developed for ranching, and it didn't really have a house to live in, they purchased the land and moved into an old log cabin. The cabin had been brought down by the previous owner from the hills west of the ranch and reassembled, log by log, on the ranch.

Although the first water rights were deeded to this ranch in 1910, it was not until the 1940s, when people named Emery bought it, that anyone ever lived on it. From its beginnings, however, the fields had been used to grow grain and hay. Lewis remembers these fields as being the best place to hunt ducks because they would gather in great numbers to eat the grain in the fields. When the Emerys came, they continued with the hay and grain, making only very few improvements, one of which was the log house.

They also started to build a new home, which never got beyond a frame.

When the Hills first moved to the ranch, they moved into the log house. After several months they had made enough improvements to the Emerys's frame to move into that dwelling. It was here that their three children were born and raised.

Lewis and Dorothy first tried running a Hereford beef cattle operation, but because the fields did not have enough sod to make good pasture, they soon sold their herd and went into the feeder business; they purchased calves that were weaned in the fall, put them on hay and grain for the winter, pastured them in summer, and sold them the following fall. Lewis spent years improving his fields for pasture, but he stuck primarily to hay and grain crops that would sustain his feeder calves.

In 1990 they retired from the cattle business and now rent their fields to neighboring ranchers. The frame of the house that came with the ranch grew many times and is now a gracious home; it also houses Lewis's television repair shop.

Facing page: Flood irrigation ditches flow through the Hills's rented-out hay fields. The water in this ditch comes from the East Fork Dam in the Skalkaho Valley, about 30 miles south of Drummond, and is part of the ditch system started by Cy Corlett and Bill Ohrmann.

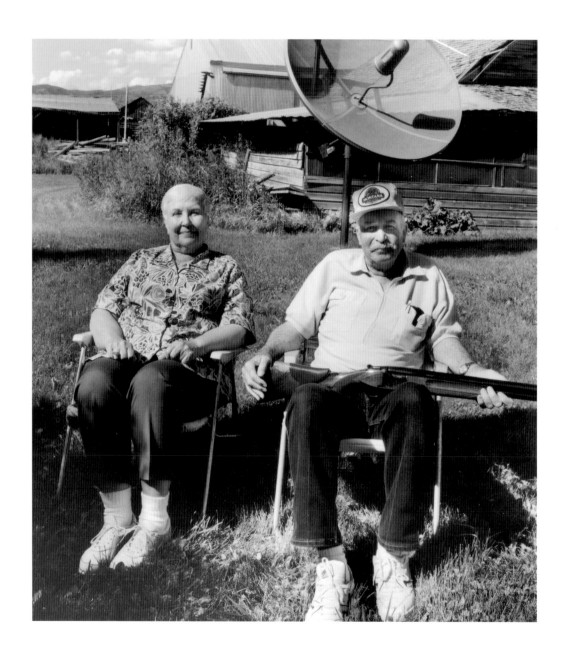

When Lewis got involved in trapshooting, typically, he would leave the ranch, and everything would fall apart in about fifteen minutes. One time, one of our neighbors stopped and said, "All of your steers are out in the road." I came out and sure enough, they'd knocked all the electric fence down. About 11 o'clock, another neighbor stopped and said, "All your steers are out in the hay pasture." So we went up and got them all back in. In the meantime the first ones got out again. And I guess I was giving Lewis hell, mentally, because when he came home, he said, "I've never had such a horrible day of shooting in my life." And he's really a champion shooter. He's got all kinds of awards. At times I wondered what on Earth we were doing on this ranch. But it was a good place to raise a family.

—DOROTHY HILL

Facing page: Lewis and Dorothy in their backyard in front of the old log house. Several years ago Lewis was inducted into the Montana Trapshooting Hall of Fame.

I was born right in New Chicago. Rick Lacey's mother, Karma, is my sister. My family came in 1915 with the first Mormon influx from Utah, after my grandfather, William, who ran the freight wagon up from northern Utah, brought back stories of thick, lush grass, in this valley. He also had the first registered Herefords in this country.

I've done a lot of things. During the War I was one of twelve people who wanted to learn to fly. Esther Corlett organized a flying club, and we took lessons. Pretty soon we thought it would be good to buy our own plane. Well, six of us were musicians, including me, and we formed a band. The other six made sandwiches, and we held dances. We got nearly enough to buy that plane, but then the war was over and everyone got busy, and the whole thing kind of fell apart.

I've retired from ranching, but I'm still the TV repairman. A man came out one day forty years ago or so, door to door, selling correspondence courses from Chicago, for fixing radios. So I did it and set up my own radio shop right here in the house. Then TV came out, and I grew into that. Color came along, and I worked with a gentleman in Drummond. When he retired in 1960, I got his Zenith franchise. Recently, I started to work for the cable franchise, too. People used to be real understanding about a rancher also being the TV repairman. But after awhile my business got so big that I started trapshooting so I could get away from all the people needing TV repairs on the weekends.

—LEWIS HILL

Sprinklers irrigate a field that Garry Mentzer rents from the Hills. Natural rainfall, in a "normal" year, is about 11 inches. It takes 33 inches of water to grow hay. There is controversy in the West about the best way to irrigate. Advocates of flood irrigation believe that despite the fact that initially it takes more water to flood a field than to sprinkle it, in the long run sprinkling is wasteful because so much water evaporates. Flood water that is not absorbed by the plants, on the other hand, returns to the ground, in what ranchers call "return flow." Without irrigation in this arid climate, whether by sprinklers or flooding, ranching on the scale that it is done today would be impossible.

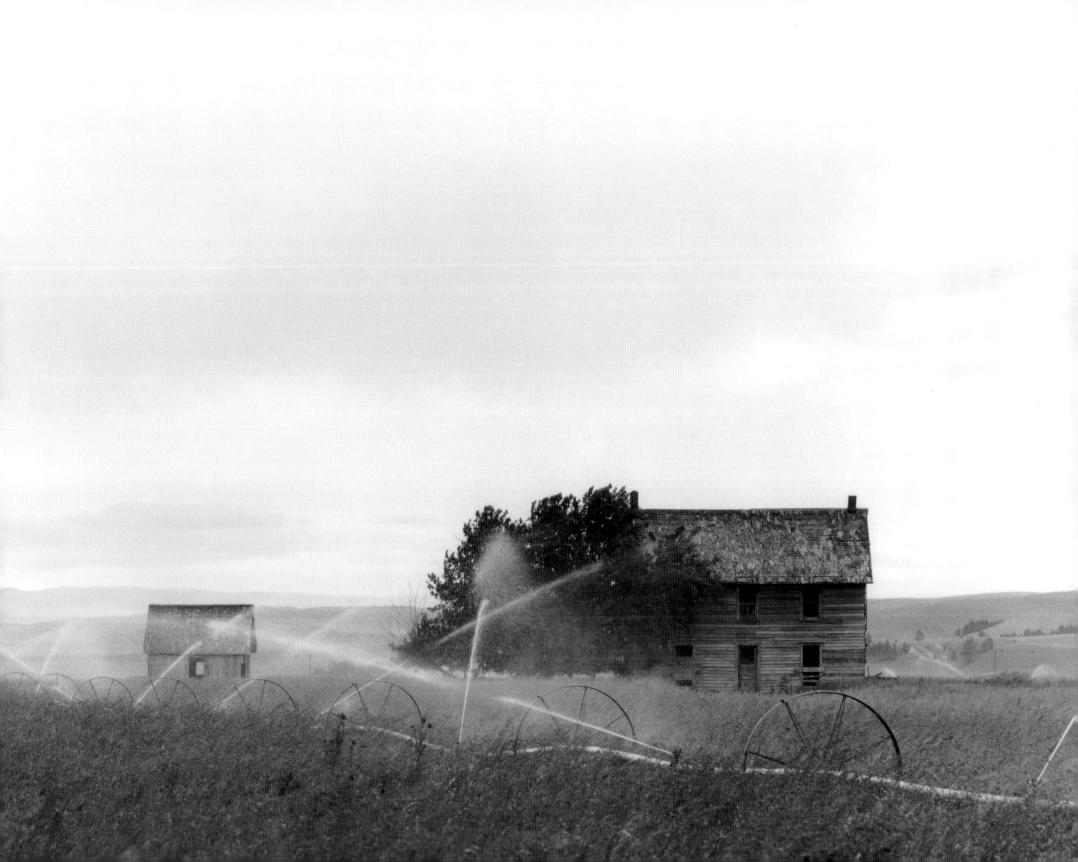

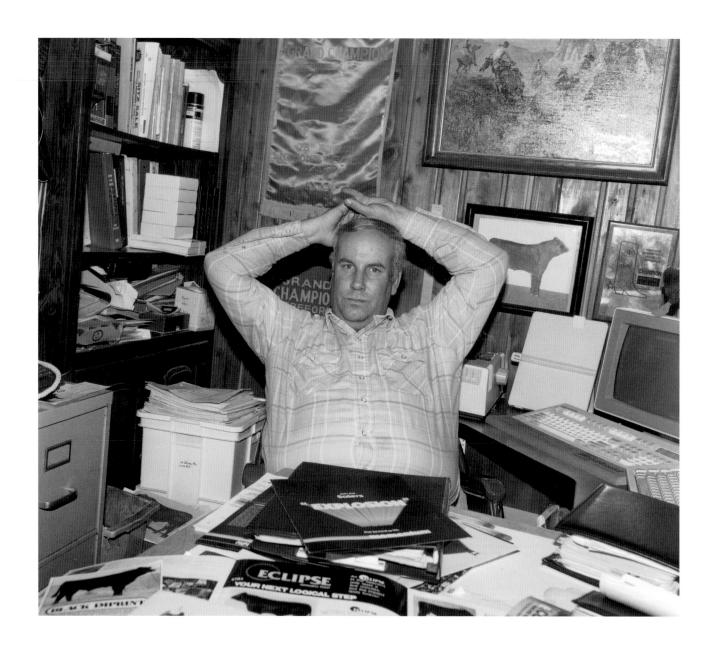

Lacey Ranches

Rick Lacey's house, the house of his foreman, and the barns and corrals are at the end of a road that runs south off of the Mullan Trail. There are tall cottonwood trees in the yard, green lawn, and the Flint Creek runs through a deep channel east of the barns. There are irrigation ditches that cut through the fertile hay fields and healthy cattle grazing in well-cared-for pastures. But people still remember when that part of the valley was more like a desert. Until water was brought over from the East Fork in Rock Creek, folks say there wasn't enough water to irrigate someone's backyard, and they remember when there were stretches of the Flint Creek that went dry in the late summer no matter how much rain and snow there had been.

The Lacey Ranches came into existence when Wayne Hill's ex-wife sold it to George and Karma Lacey, Rick Lacey's father and mother, in the late 1950s. Wayne is Karma and Lewis Hill's brother. The property was originally part of their father John Hill's large spread that included much of the Verlanics's place, which Hill created when he came from Utah in 1915. John Hill developed and showed his registered Herefords throughout the western states and won many trophies. When Rick took over he also had Herefords but then added Saler, Red and Black Gelbvieh, and Black Angus. The Salers and Gelbviehs are leaner cattle, and the Angus add hybrid vigor to his bulls.

Rick prides himself on being in the forefront of a new way of raising and selling beef cattle. He is an articulate spokesman for technologically sophisticated methods of genetic breeding that will produce leaner, more tender beef. His office is filled with computers, fax machines, and awards his cattle have won. He is a passionate believer in marketing and is certain that the rancher of the future will have to be as good at selling as he is at raising healthy cattle.

Rick spends much of his time on the road putting his mouth where his money is, so to speak, lecturing to cattle producers and wholesaler associations. He leaves much of the day-to-day operation of his ranch to his very capable foreman, Scott Mackay. When he is not on the road, Rick is deeply involved in the Mormon Church, in which he is an Elder; he has also served as Counselor and Branch President, important functions in a lay-led denomination. His wife, Linda, a concert violinist with the Missoula Symphony Orchestra, stays in the background of the ranching operation but also displays the same drive and energy as her husband, dividing her time between her own music, teaching music to others, tending to the two of their seven children who still live at home, and teaching daily religion classes at the Mormon Church.

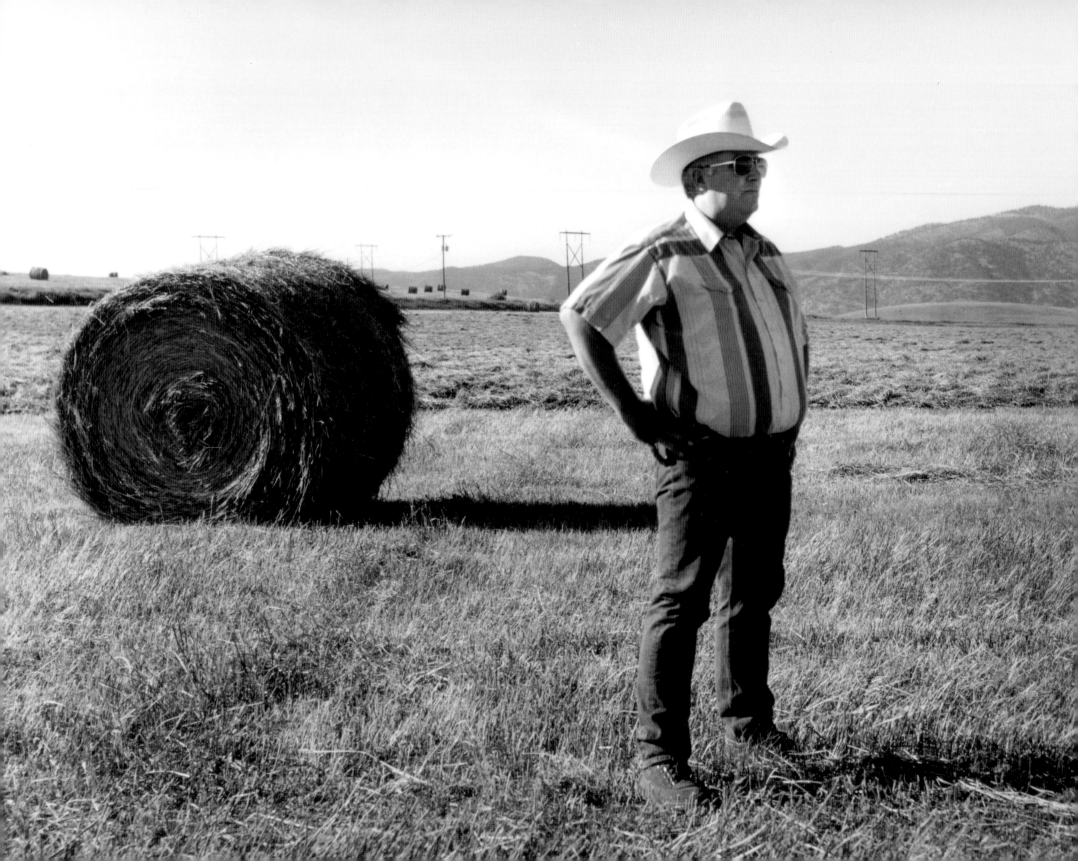

My grandfather, John Hill, came up from Wellsville, Utah, as an agent for the Utah Mortgage and Title Company in 1915. A major ranch in this valley had gone broke, the Allendale Ranch Company. They owned clear up on the hillsides and down in the valley here, almost all the way to Drummond. As the real estate agent for that company, he got the heart of it for his homestead. He brought fourteen other families up here with him from the Mormon community in Wellsville. So they kind of colonized this part of the valley. When they came up, they brought their farming activities with them. They thought they could raise corn, and so they built silos. That lasted a year until it frosted in the summer, so some of them went broke and moved on. But Grandfather stayed here and built a good business. It took years before they were not considered new move-ins or outsiders. And even when I was a kid, I know that the old families of this valley considered our family a new family, even though they'd been here since 1915. But in a small community everybody needs the other person. In a small community there really isn't any space to exclude people. And I think that's what happens in a small community—if you want prejudice to go away and really want things to work, it'll work. If I were to have an accident here, I would find the same proportion, or maybe more, of people who were not of our faith coming to help. I don't care about a person's faith when it comes time to help them. I think that this community epitomizes that. You can just feel it here.

—RICK LACEY (FACING PAGE), OWNER, LACEY RANCHES,

NEW CHICAGO

've been in Drummond almost seven years. I worked before that with my father, and we got caught up in the excitement of the 80s and went broke. So Rick called me up in 1985. We talked several times, I came up for an interview, saw the cattle, and here I am.

One of my priorities is my family. One of the reasons I stay in Drummond is that here I get to have my family to work with me. My children all learned to work early. My philosophy is that kids who can't do anything, who aren't asked to do anything, don't have any self-esteem. You worry about kids growing up today, but if they have self-confidence, then they don't have to prove themselves every time they turn around. My sons are all smart. My oldest has a 4.0 average in high school, and he's a good worker. Sports can do that, but sports only last through high school for most kids. So they have to have their confidence level built on something more. And when kids aren't involved in sports, then they're lost. My kids will have a lot to fall back on. We always talk about the cattle, and they ask me if I like this one or that one, and I have to say I have to look at their calves. Genetics is everything, and it just fascinates me. That's why I have six good-looking kids. I got a good-looking wife. I knew how to plan.

—SCOTT MACKAY, FOREMAN, LACEY RANCHES

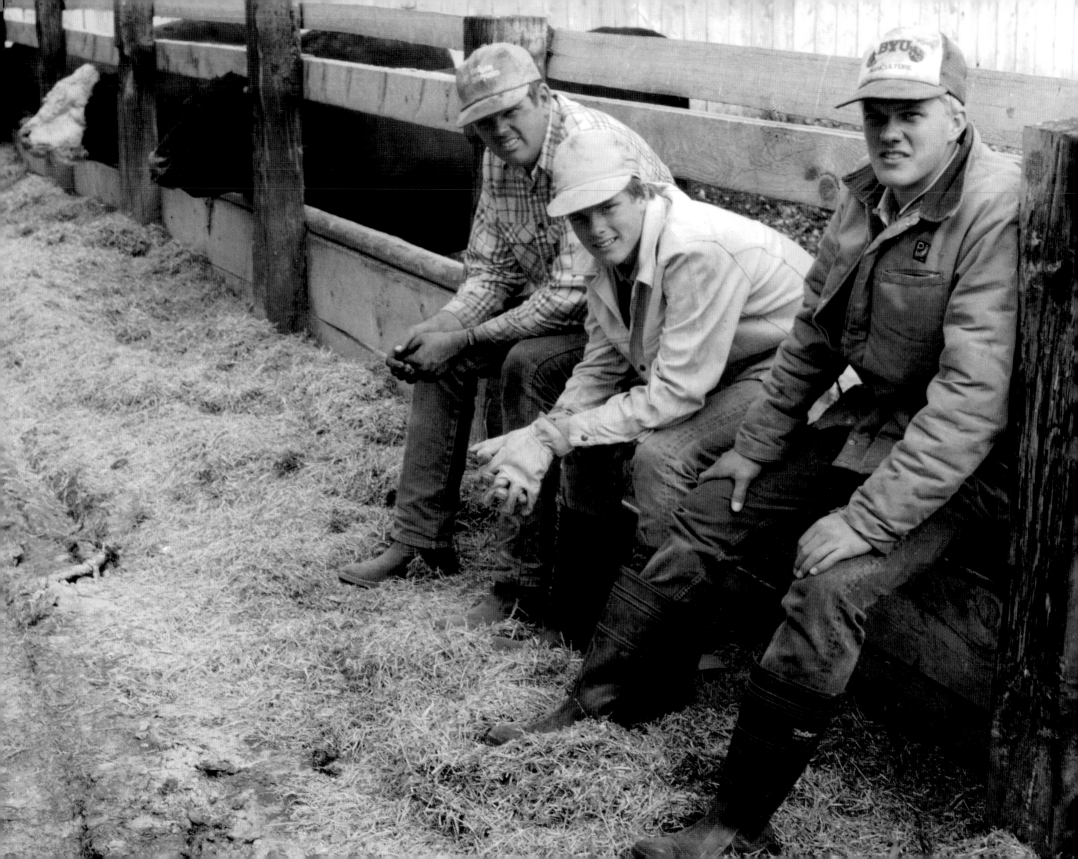

Facing page: Scott Mackay, left, with two of his sons, Brett and Wes

Right: Anna Mackay, fourth of Scott and Aline's six children, works in the garden behind their house.

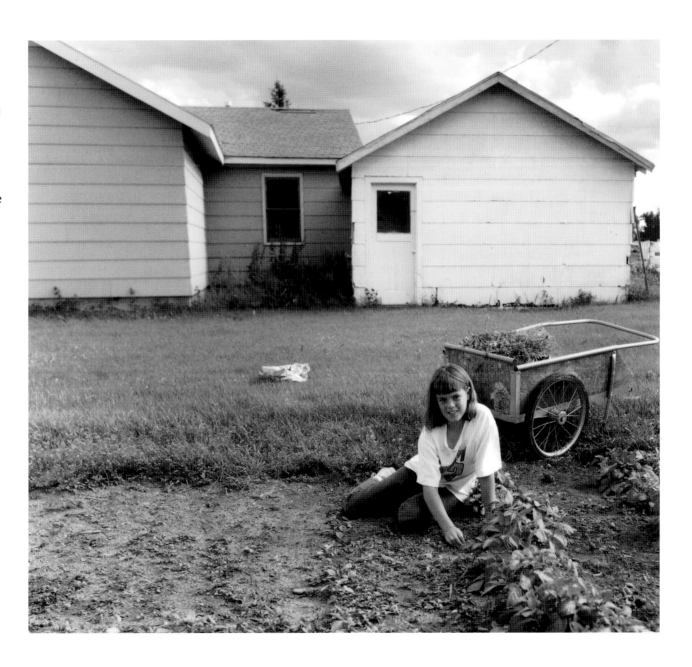

Left: Sherman Holgate (right), a trainer and groomer from Missoula, shows Brent Lacey and Brett Mackay (left) how to calm their 4-H Saler calves.

Facing page: Brent checks calves born in the field.

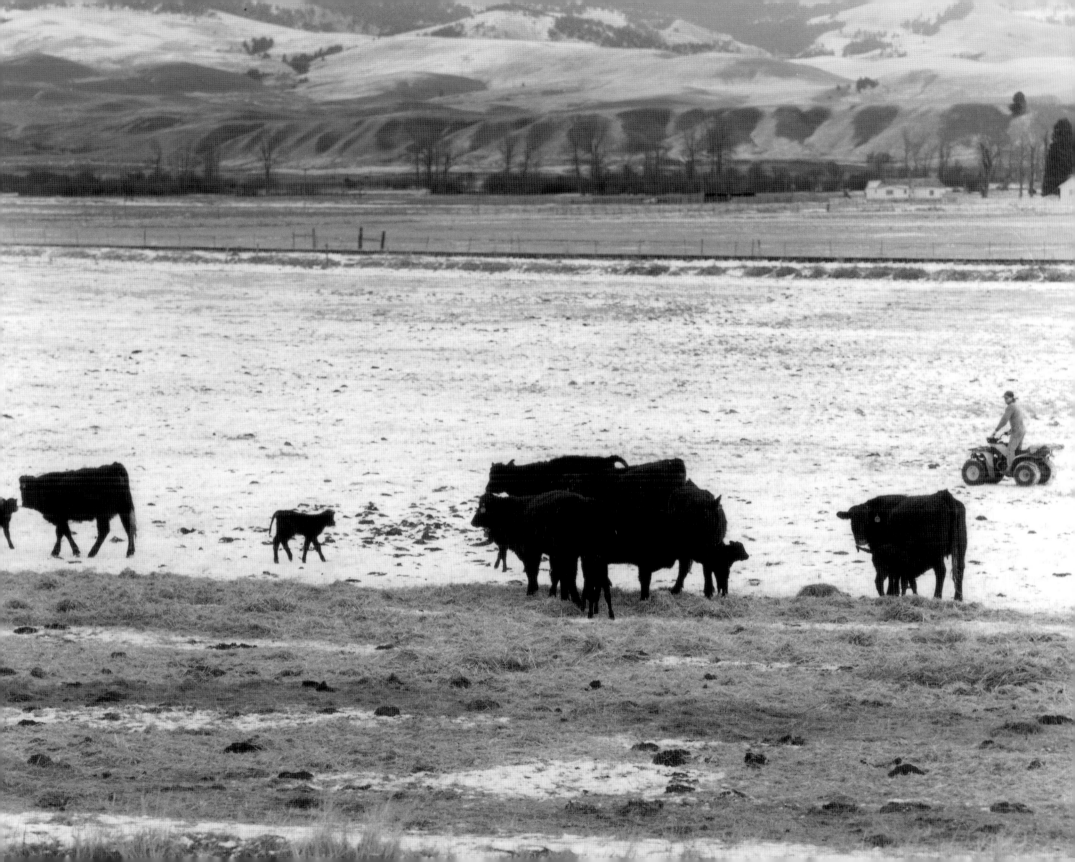

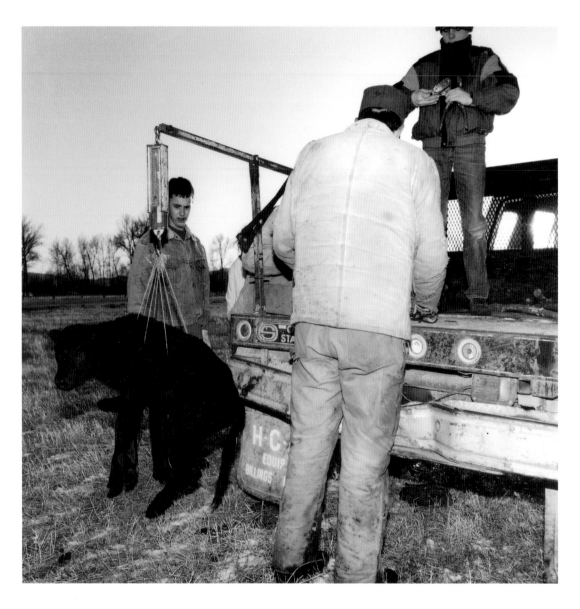

Scott weighs, tags, and inoculates calves with two of his sons, Brett and Allen.

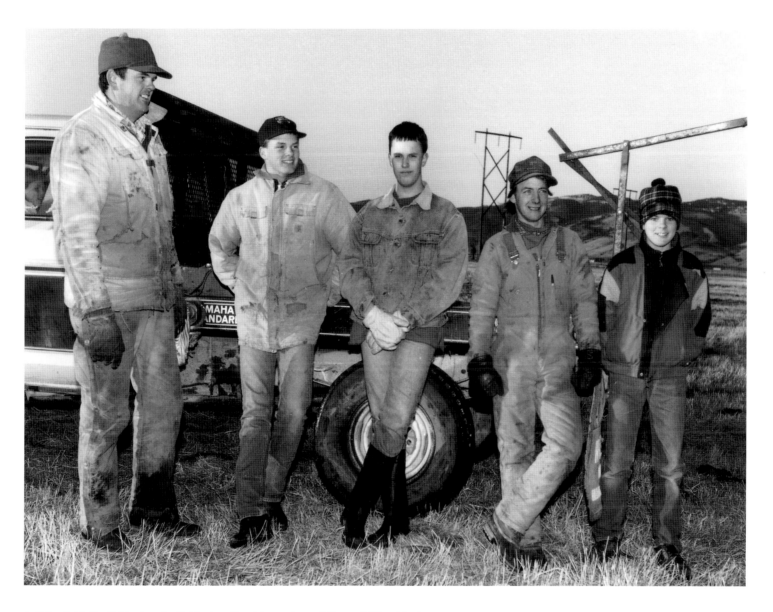

Left to right: Scott Mackay, Brett Mackay, Brent Lacey, Larry Fritz, and Allen Mackay

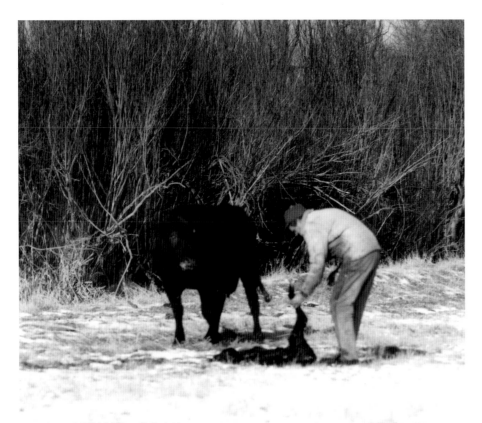 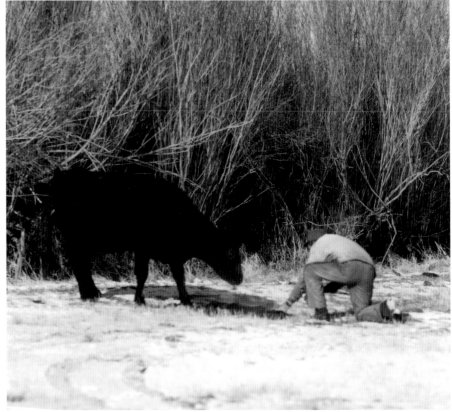

Y ou're really lucky to be able to see a birth. Cattle are very private and don't need our help, usually. But every once in a while, like this one, a calf is born with the bubble intact, which the mama can't break, and which can kill a calf in no time. It took her a minute to let me talk her into letting me break that placenta. My wife doesn't like watching the calving. She says it's too graphic. She says every time she watches, she remembers giving birth, too. But it's good we were here. We would have lost this one otherwise.

—SCOTT MACKAY

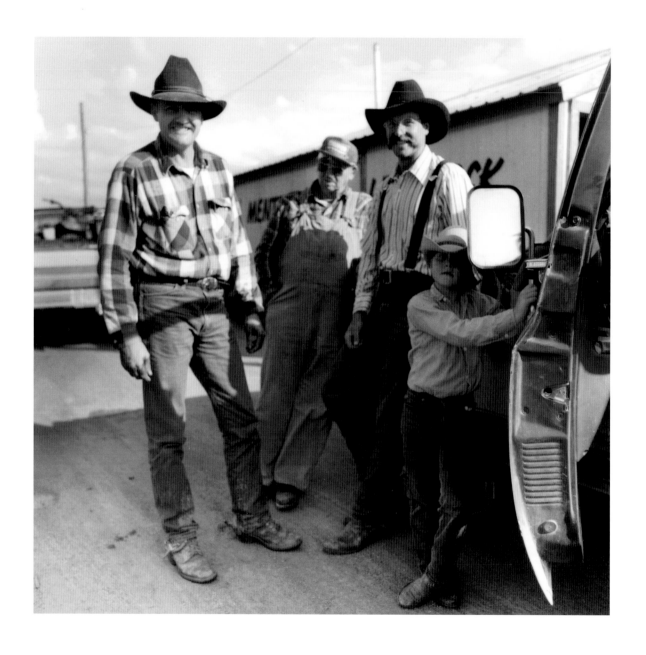

Calvin and Harriet Mentzer

If you turn right onto the Old Mullan Trail just after Bill Ohrmann's place and head west until you've crested the big hill, you will see the Mentzers's ranch below you on the right. Calvin and Harriet Mentzer grew up together and have struggled over the years to make a life for themselves and their four children. The ranch they own now was part of a ranch owned by Bert Allen, who took a liking to Calvin. Allen also had had to do whatever it took to get by, including working as a timber faller, which is what Calvin does to make ends meet.

The remnants of stone foundations where his corrals are now and the top edge of a hand-dug well that Calvin filled in with foundation stones are all that are left of earlier ranch buildings. Teepee rings that are clearly visible in early spring when the grass is coming up and flint stones and arrowheads buried in a small area near the rings lead Calvin and his children to believe that there was a regular Indian encampment on the hill to the east of where their double-wide trailer home stands.

Calvin raises commercial Charolais/Angus beef cattle and bulls. He likes Charolais because his father-in-law raised them too. Harriet's father was the first in the valley to take what were then called novelty varieties, French cattle that are now sought after because they produce naturally leaner beef. The Mentzers also raise paint (pinto) horses, something they started doing when their oldest child, Teresa, wanted to have something different for a 4-H project.

In July 1995 Teresa married Rhett Rigby, a rodeo rider turned blacksmith. They moved to Havre, on the northern tier of Montana, to go to school. One of the wedding presents she received was a bull calf from the Corletts, who also got her started with her herd when they gave her one of their orphan calves to raise. Her father is taking care of her herd until she and Rhett are fully settled.

Facing page: Calvin Mentzer (left) with Al Kinzle,
Mark Tisdell, and Roy—Mark's son

My parents are from here, but we used to rent a place in Choteau, and I loved it there. So when I first came here, I didn't like it here at all. It took me a long, long time till I got used to the bare hills and no trees, but now every time I come over the hill and I see our place, and I know that we own it, it makes me feel really good.

I love animals, and I love to work. I started with one calf that was given to me, and now I have twenty-four head of cattle, which are my college money. My sister drives the truck while I feed, but other than that, I take care of my animals myself.

—TERESA MENTZER

My wife and I were both raised here in the valley. I'm the youngest of seven kids. After I got out of the service, we lived down at her folks' place, west of Drummond and kind of got started ranching over there. Then they sold their place to my older brother Garry in '73. My dad was still alive then, but we weren't established enough when he got sick and died of brain cancer, so Garry, who was better established, got the home place. So we leased Harriet's parents' place from the man who bought it. After about four years we had a difference of opinion, and we just kind of parted ways.

Then we found a place up west of Choteau for five years and then at another ranch there for three years. That was in '85. Then things just weren't working out for us, so we moved back here to Drummond where we both grew up. Then one thing led to another. We first lived in town, and I leased a little piece there, and then we had this leased, and another piece of property. Then the gentleman that we were leasing this from set it up so we could buy it. At that time I was working in the woods and training horses—whatever it took to get by. Well, he had come up that way himself, and he appreciated somebody who has energy enough to get out and hustle. So he set it up for us, and basically this is where we're at.

At times it gets frustrating because it's hard to make ends meet. In this day and age, you have to work every angle imaginable to try to make a living and raise a family. If it weren't for my wife's job as a registered nurse, I'd probably starve to death. Sometimes it gets so frustrating I'd like to scream. We've been fortunate, though, to be able to live the life that we've both grown up in and known. Even if I won the lottery, I wouldn't change my lifestyle. I might have a fancier place, but I wouldn't change. Like I've always dreamed of having a big indoor arena. I'm an avid horseman, and I'd like to start roping here. That's my dream.

—CALVIN MENTZER

Facing page: Teresa Mentzer (left) and her sister Amanda

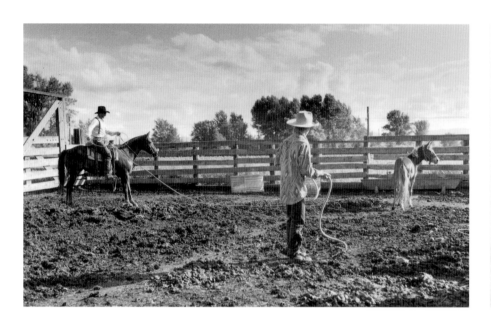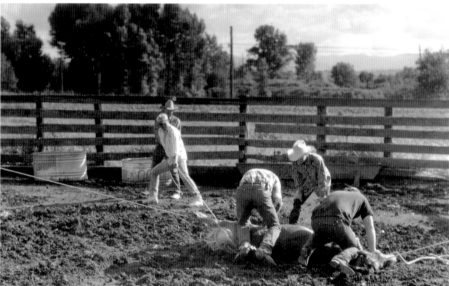

Calvin, Scott Struna, Kay and Mark Tisdell castrate a mule at Mentzer's Stockyards.

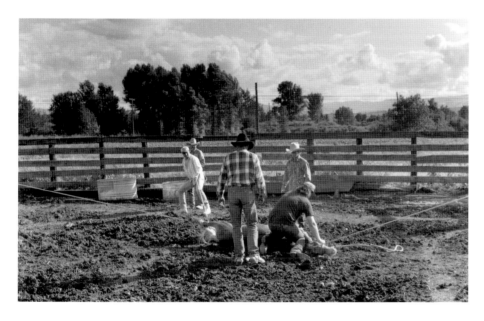 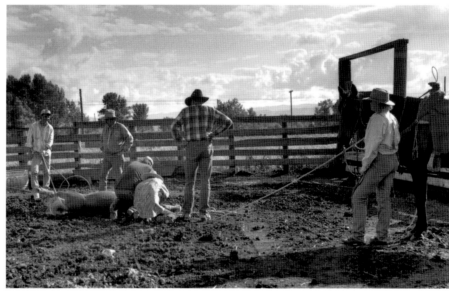

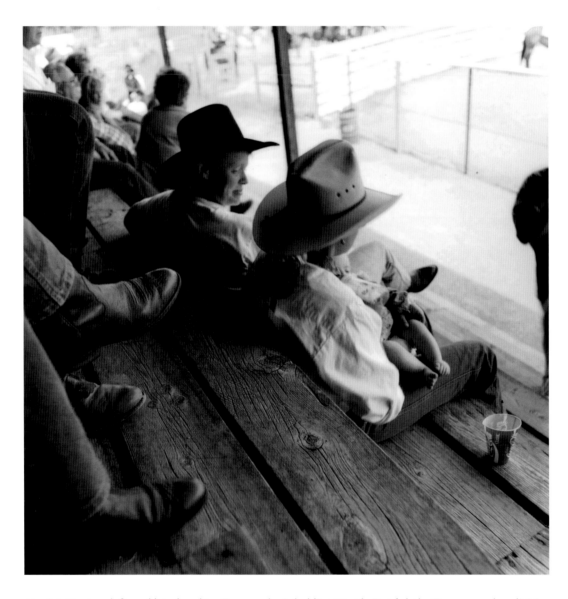

Harriet Mentzer, left, and her daughter Teresa, who is holding Wendy Dyer's baby. Teresa won her division.

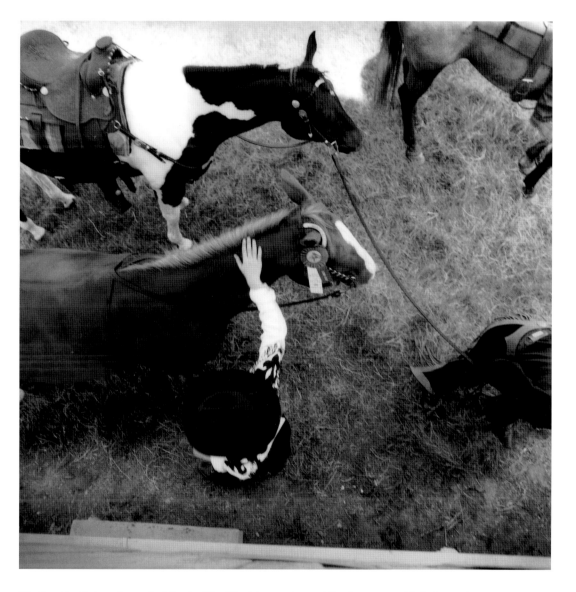

Waiting for the next event at Best of the West horse show at the Drummond Fair Grounds

make my living as a cowboy, and Kay works right along with me. One ranch we worked on in Wyoming was about 85 miles long and about 45 miles wide, and we worked from one end of it to another. We'd live in camps where we never had a phone, and a lot of times we never had electricity. In the summer we'd get up by 3 A.M., work 'til noon, shade up after lunch, rope and shoe horses after the heat of the day, and then play cribbage at night. One summer we kept track, and we played something like three or four hundred games—most of which she won—and I found out not that long ago that she cheated the whole time. Now I know people will think I'm really, really slow, not to figure it out after 400 games, but I never dreamed anyone would ever cheat at cards out there—not where there was no money involved. She says she did it just to keep me from getting cocky. It must have worked, though, because I'm happy if we can work and be together. After our kids are grown, we want to go back to some big ranch and hire on again, just to be out there by ourselves. Maybe we'll even play some cribbage.

—MARK TISDELL

Facing page: Mark Tisdell, after roping practice, and his wife, Kay (Calvin and Garry Mentzer's cousin). The Tisdells moved back to Montana when their children were born, and now work the Mentzer "home" ranch in Hall, where Garry and Calvin were raised.

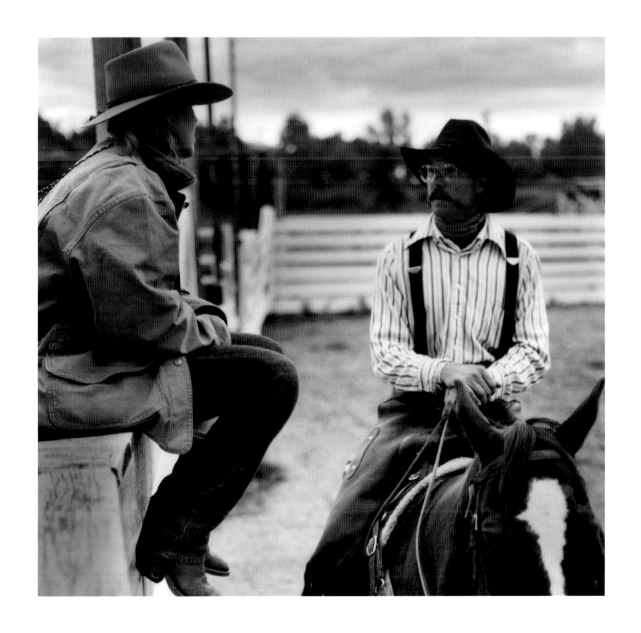

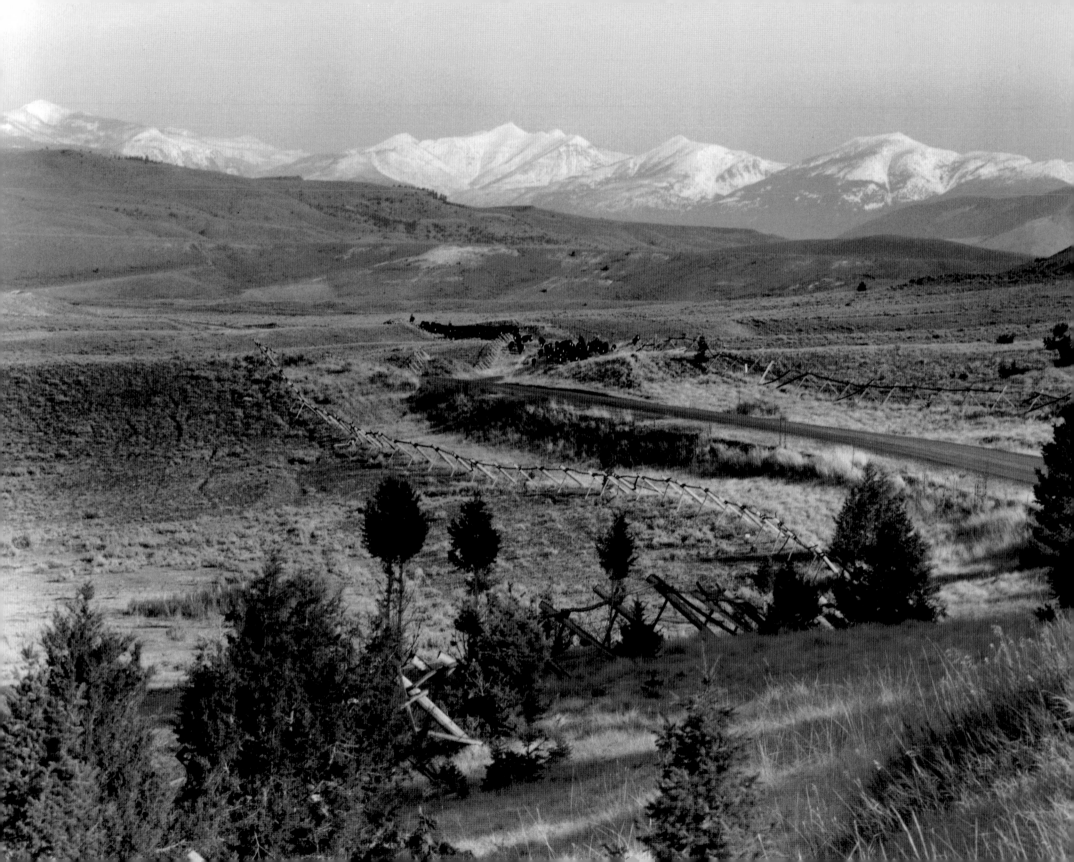

The Verlanic Ranch

Joe and Sheila Verlanic and their son Pat and his wife and three sons raise commercial Angus on one of the oldest ranches in New Chicago, with water rights dating from 1873. The ranch was put together by John Featherman, who came to the valley in 1870, and who was one of the founders of New Chicago. He built a log cabin that still stands; it is across the road from the sturdy brick house he built in 1886, the house the Verlanics now live in. The house itself is not on the ranch property but was in the city limits of New Chicago and, as such, was considered a town property of some value. Jack Nelson's parents owned it from 1919 until 1921, when they sold it to move back to their family place on the outskirts of town. Several others owned the ranch, including John Hill, the original Mormon settler who came to the area in 1915. By the time Hill owned it, the ranch was large enough so that when he sold it in the 1940s he was able to split the property, creating two ranches, one of which is now the Lacey Ranches, and still leave a large spread. The next owners sold off about 4,000 acres more before selling to the Verlanics in 1982.

Joe's father and uncle came to America in 1901 with their father, sister, and stepmother. After they had established their sons in Anaconda, which is about 70 miles to the south and east of Drummond, the parents and sister returned to Slovenia, leaving the two boys behind to fend for themselves. The boys went to work milking cows for a local dairy, saved their money, and eventually purchased their own dairy farm. Joe was born on that farm in 1931. In 1952 he married Sheila, purchased a ranch in Rock Creek—a beautiful, isolated valley with chronic water problems, about 35 miles south of Drummond—and they spent the next thirty years ranching and raising four children. They bought their present ranch in Drummond when one of their sons, Pat, wanted to ranch with his father.

Pat and his family live about a mile down the road in a house they built in the old picnic grove. This wooded area was originally purchased by Featherman as a timber homestead. Part of the Homestead Act allowed homesteaders to add an additional forty acres to their land if they would plant trees. Until Pat built his house there in 1983, it was simply a circular stand of poplars that not only marked the picnic grounds but also marked the far end of the horse racing course that ran on the road between there and the Mullan Trail, about a mile to the north.

Facing page: The Verlanics's cattle, on their way from their summer pastures in the Helmville Valley to their winter grazing in Drummond, pass through the Manley Ranch on the Helmville road.

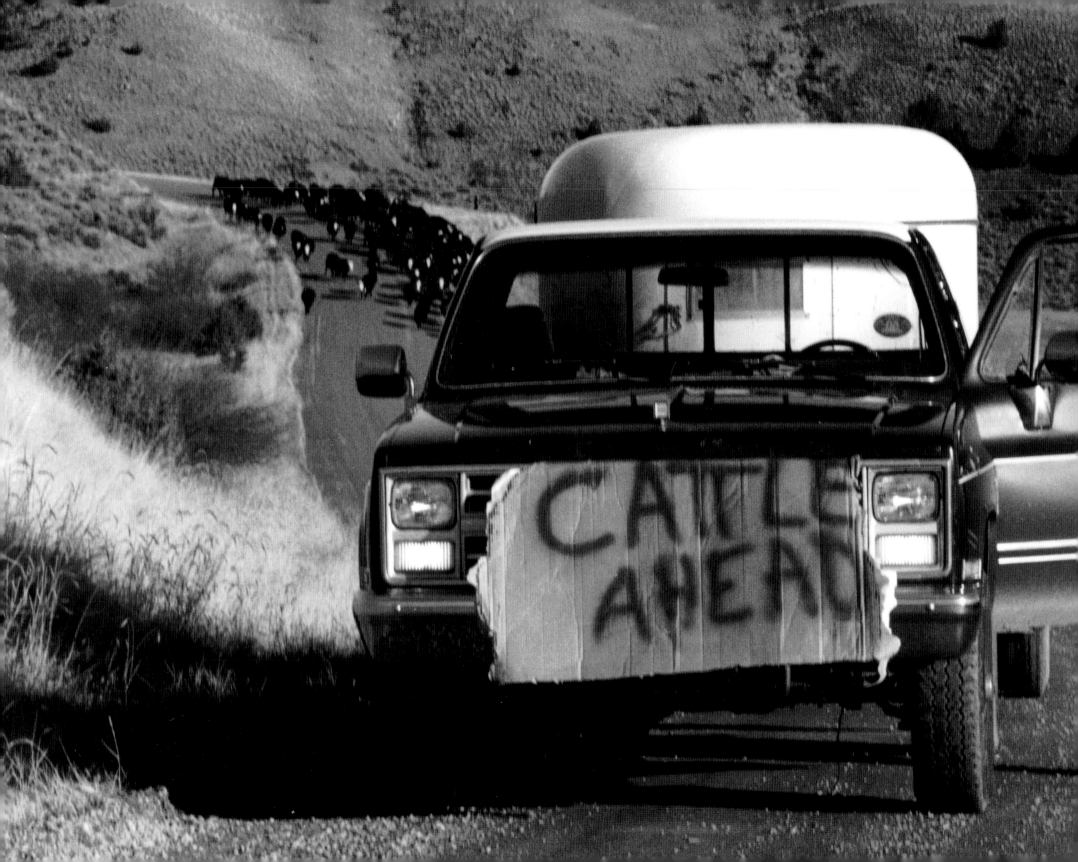

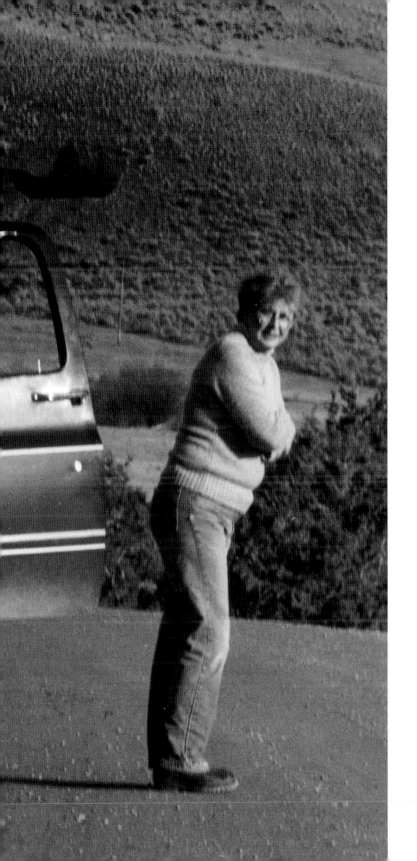

There's a lot of waiting when we're driving the cattle back to the ranch from Helmville in the fall. It's amazing how fast the cars come up and down this dirt road. The sign helps, if they're coming toward the cattle. The cattle don't mind either when cars come in this direction and they can see them. It's harder for them and for the men, though, when they come from behind. They tend to scatter. For me it's not so bad, though. It's easy work, and I kind of like it. I have my big thermos of coffee in the back of the truck, and that keeps me going.

—SHEILA VERLANIC

Joe Verlanic waits in chilly dense fog.

It was John Dingwall who said, "Winter's fog will freeze a dog." I remember the day he said it: It was in the wintertime, and we had a lot of snow here, and we had horses in the upper pasture. He and I started up on horseback to get those horses, and it was probably zero, maybe even a little colder than that, and the snow was deep. The fog was just like it was here the other day. And just for a few minutes after we ate our lunch with our mitts on up there, why the sun came out and we were able to find those horses and get them and start for home. But that day when we were going out, it was so cold and miserable, he said, "Winter's fog would freeze a dog."

—JACK NELSON, RANCHER, OWNER OF WILLIAM DINGWALL COMPANY

Every rancher is a neighbor. We all have the same circumstances, all have the same problems. And we all exchange work. We don't hire people unless we absolutely have to. Neighbors come and help—and then we go and help. It's our valley, and we take care of each other.

—JAN MANLEY

On following pages: Left to right, Pat Verlanic, Ron Wetsch, Jack Nelson, Ken Bloom, and Kenny Verlanic—Pat's brother—at the end of a two-day drive from the Helmville Valley to the Verlanic Ranch

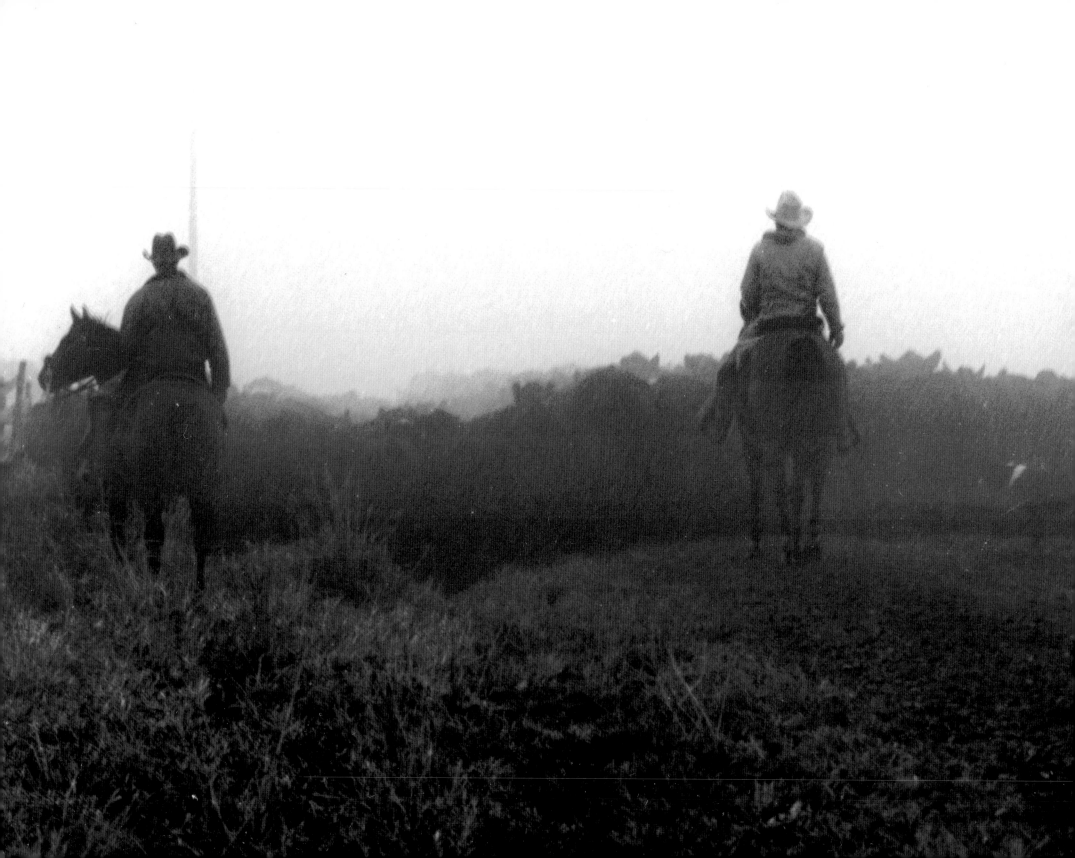

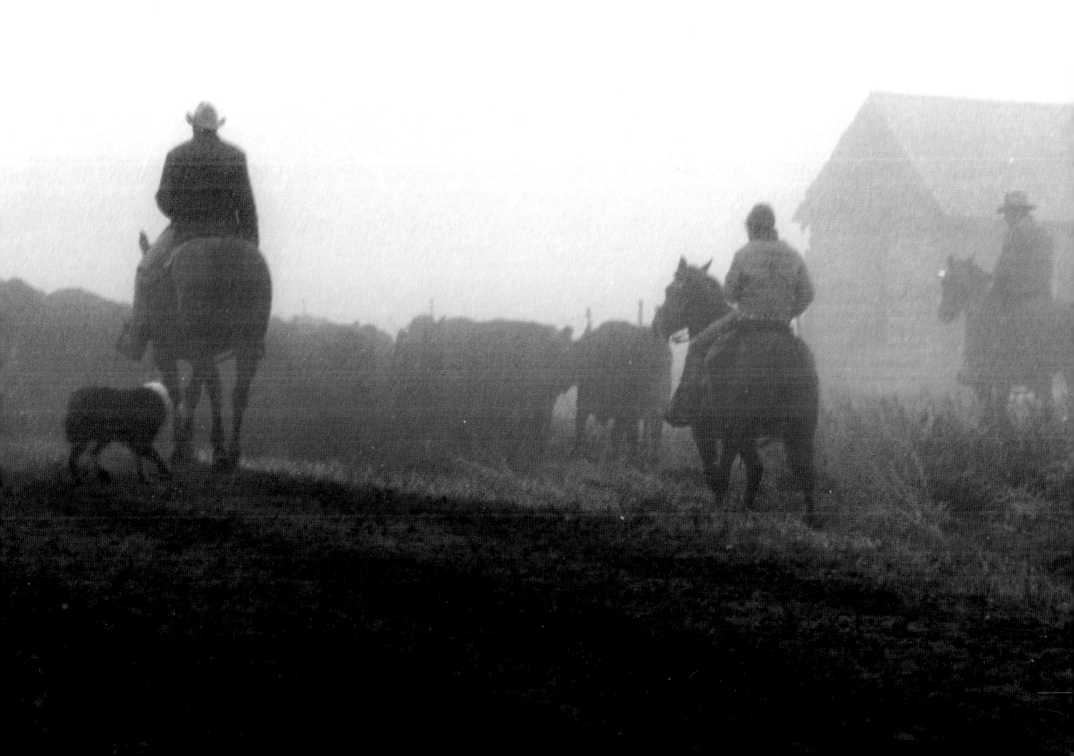

Castration isn't pleasant. You know that it hurts that animal, and like I said, we spend so much time, you wouldn't believe the hours we spend calving these cows out and the work we do to get these calves on the ground and get them up and get them going. Watching them for probably the first two months of their life is the most critical part of it. You know they get scours, which is a diarrhea, and pneumonia and die. And they eat dirt. They're like little kids. They'll get out here on a bank, and they'll start eating dirt, and they get an ulcer and it perforates their stomach and they die. And all kinds of things. One time I put out some new salt, and we lost three calves that night. They gorged themselves on that new salt, and it burnt their system up. So there's always something.

And then when you turn around and brand and castrate and inoculate them, why you know you're hurting them and setting them back. It's the same thing weaning calves. You take them away from their mothers and you stress them, and they get sick. Some of them will get sick and get pneumonia or something. Or if they have a little something wrong with them, it doesn't take too much to trigger it, whether it be an animal disease or something of that sort.

I also don't like to see people abusing my animals, even after they don't belong to me any more. I used to keep heifers and breed them and sell them, and twice in my life I delivered heifers to places where I didn't want to unload them. I wanted to bring them home. A year after I unloaded one bunch, this guy's nephew told me, "If you saw those heifers you sold that man, you wouldn't even know them." So after that I would rather they went to slaughter than go off to somebody to abuse. You don't enjoy those kind of things. We spend too much time getting them on their feet and getting them going.

—JACK NELSON

132

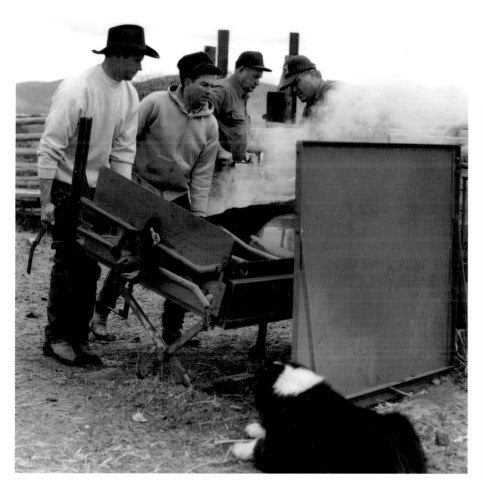
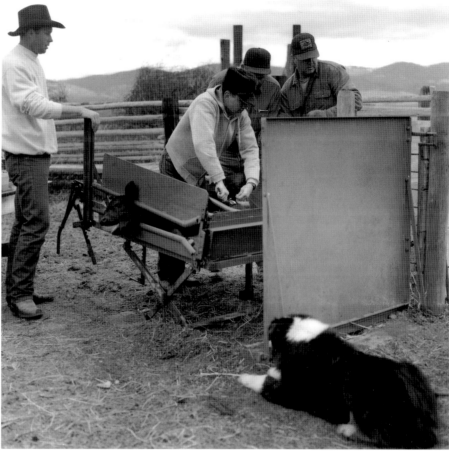

Left to right: Pat Verlanic, Ron Wetsch, Joe Verlanic, and Jim Struna brand and castrate Verlanic's calves.

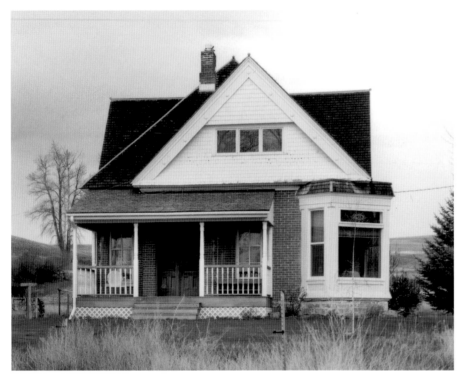

The John Featherman house is now the Verlanics's spacious and comfortable home.

When the kids were little and in diapers, we still lived in Anaconda. We had our ranch out in Rock Creek, but it was so remote, not even on a county road, that during the winter we had a hired man who lived there because it was too cut off with the kids and all. But in the summer we'd go out during haying. All I had was the wood stove, you know. I think of that often and think that disposable diapers came along way too late. We didn't have electricity until I don't know when. We had kerosene lamps, an Aladdin lamp, and an ice box. The house had been vacant during the war. They had taken everything out—the plumbing and pipes and everything. We did get the spring going and put in cold running water. Then we put the hot water jacket in with the wood stove, and so we had hot and cold running water even before we had electricity. But the only thing was in the summer, when everyone was haying, when everyone wanted a bath, you had to keep the stove going during the heat of the day. Oh, it wasn't fun.

—SHEILA VERLANIC

Joe Verlanic's dog waiting for a handout. Pat and Carrie Verlanic's brand is on the left; Joe and Shelia's is on the right.

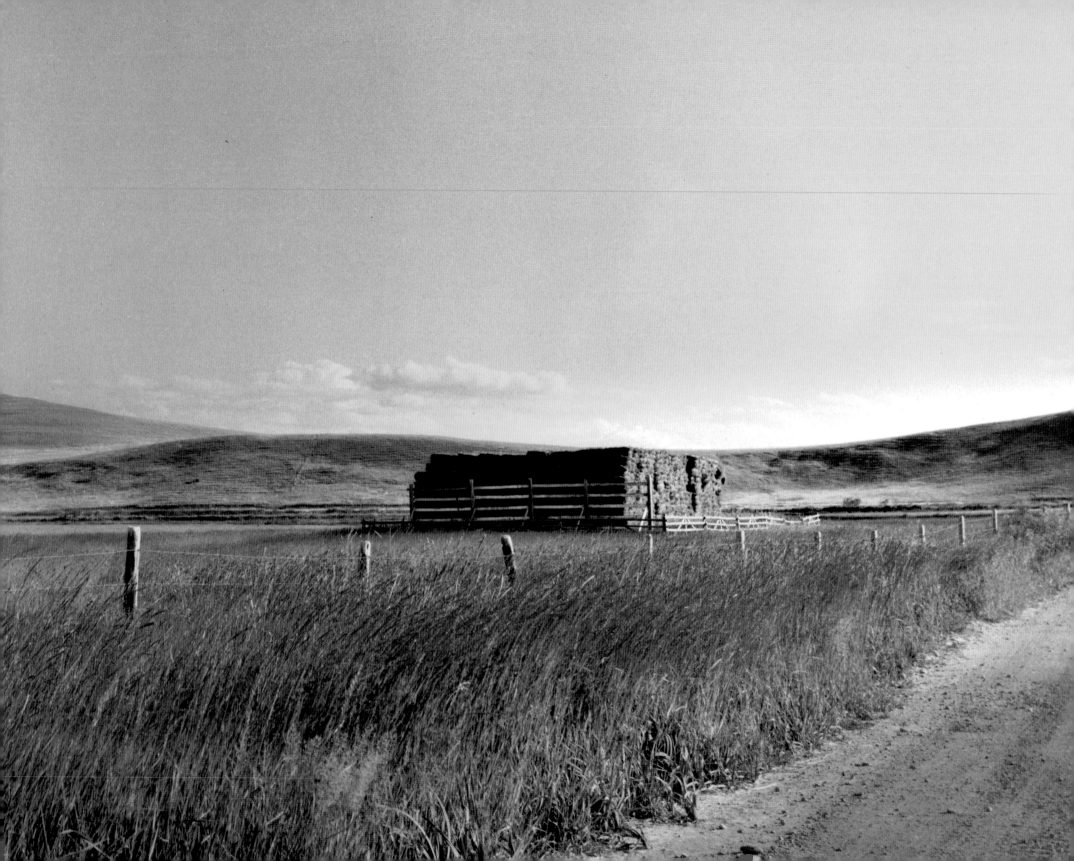

The William Dingwall Company

The William Dingwall Company Ranch raises crossbreed and registered polled (hornless) Hereford beef cattle. It was created in 1878 by Duncan and William Dingwall, who passed it on to William's four children, John, Jim, Will, and Leona, none of whom ever married. They left the ranch to Jack Nelson, who had worked for them since he was a boy.

Duncan and William Dingwall were born in Scotland, immigrated to Canada, came up the Missouri River to Fort Benton in the 1870s, and walked to Helena, where they went into the lumber business for a couple of years, then walked to the Flint Creek Valley and decided they wanted to stay there. So they cut some hay with scythes, put it up, went back to Helena, purchased some milk cows, drove them back to the valley, to the town of New Chicago, and went into business hauling milk and butter up to the local mines. One winter, however, Duncan had to have a foot amputated after it froze in a blizzard, so they opened a store in New Chicago and had people come to them. Then they began, as many future ranchers did, to acquire property on unpaid grocery bills or by acquiring the rights to abandoned homesteads. When they finally decided to start ranching, they had one of the largest and prettiest properties in the valley. The brothers and their families continued to stay in their homes in town, however, keeping the store and working the ranch with hired help. The last of that generation, William, died in 1928, when Jack was eight years old. The original Dingwall home, which is owned by the William Dingwall Company Ranch, still stands across from where Joe and Sheila Verlanic live, in what remains of the town of New Chicago.

Jack Nelson, born in 1920, grew up on his family's place on the edge of New Chicago. His father had a butcher wagon and sold meats to ranchers and farmers in the area. The family also lived for a brief time in the house now owned by the Verlanics, across the road from the Dingwalls, which was when Jack met them. They took a fancy to him, gave him summer jobs until he got out of high school, and then hired him full time to work the ranch for them.

Onita Nelson, also born in 1920, grew up in Hall and became the chauffeur for Leona Dingwall while she was still in high school. She continued to drive for Leona after she and Jack were married in 1942. Neither of the elder Dingwalls, nor their son John, ever lived on the ranch, but Jim and Leona built themselves a place on the northern edge of the ranch, along the Clark Fork. When Onita and Jack married, they made their home on the ranch. Will died in 1945, but Jack, John, and Jim ranched together until the brothers died (John in 1956 and Jim in 1960). Onita continued to work and care for Leona until her death in 1968. Jack and Onita raised two children, a son, Gordon, who did not stay on the ranch, and a daughter, Joy Wetsch, who lives next to her parents in the Dingwall house with her husband, Ron, and their sons Shawn and Justin.

have always had a soft spot for horses. I was born and raised driving horses. I have a soft spot for them, always have. I love to drive a team. And I like to ride. I used to have this horse that I rode when we were working in the fields. I used to ride that mare home all the time. Now we're mechanized. Last summer was the first time in fifty years that I didn't have to have a hired man. My grandson Shawn and my son-in-law, Ron, and I ran the whole place in air-conditioned tractors. But I still like to get out and ride out across the pastures here. Do something. Chase cattle around. When I have to give that up, I guess I'll give up altogether then.

—JACK NELSON

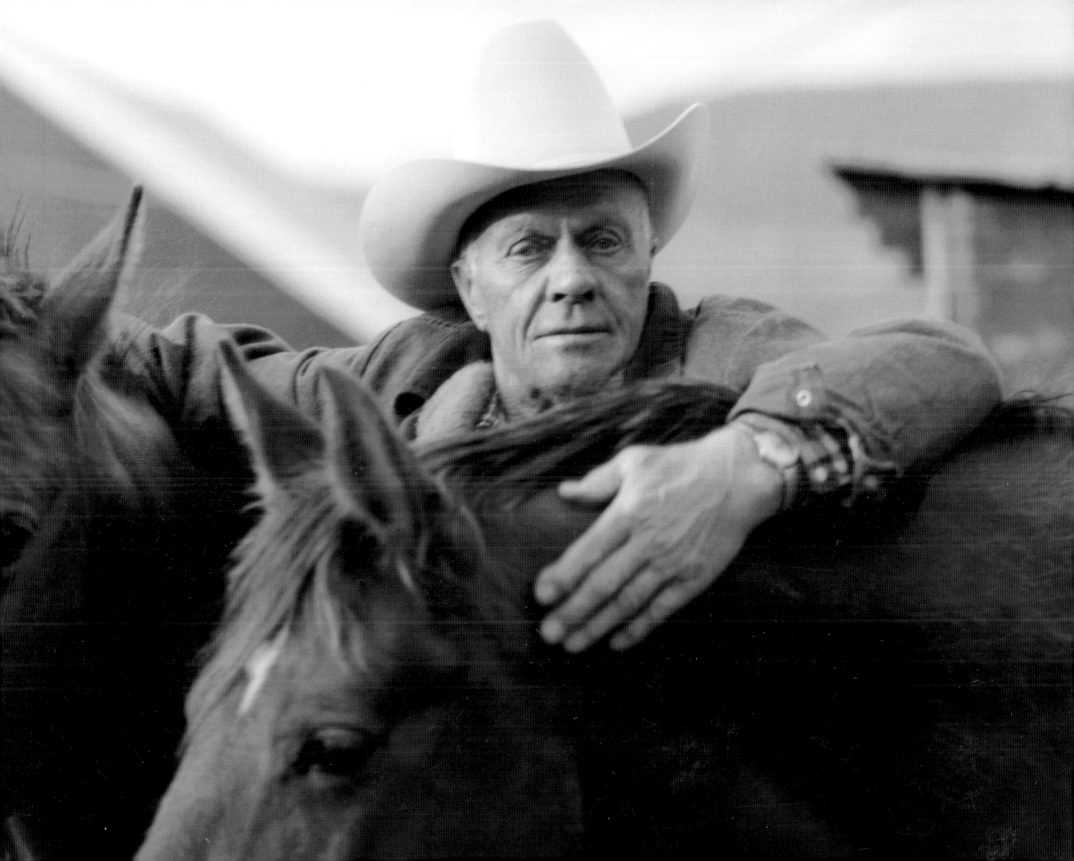

Raising cattle is a gamble. You never know what you're going to get for them. It makes most gamblers look like pikers—being a cattle producer. The prices go up and down for no reason. It's the futures market causes this fluctuation, and the price of grain, which is also determined by the futures market. The producer gets less out of these animals than anybody does. We have to own them for a year, plus their mothers for a lifetime. And we get less money than the feedlot buyers who handle them for maybe twenty-four hours.

I don't know. I guess it's that we're not smart enough to know what we're doing. We're busy with our hands while they're busy with their heads—they know where they've got us—right out on the end of the stick on everything. It doesn't make any difference if you're a rancher or a farmer, there's no place to go. You can't pass your losses on to anybody else—there's no way to do it. So we don't know from sale to sale if we're going to make a profit or if we're going lose on it.

—JACK NELSON

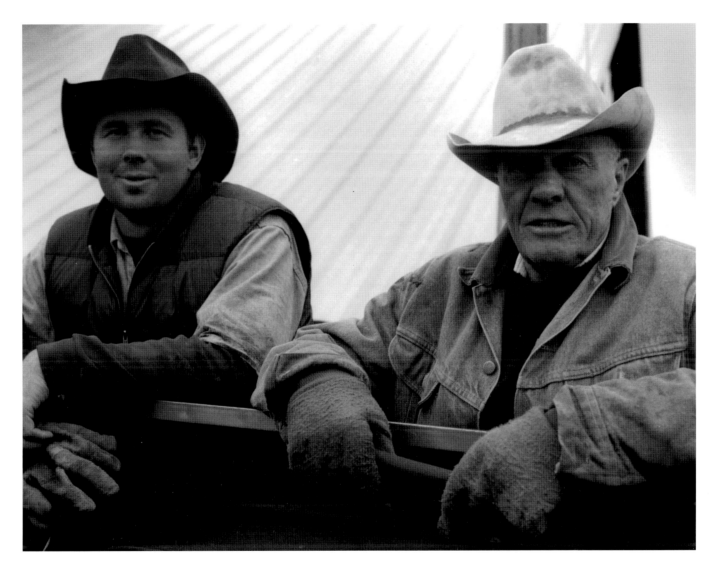

Jack Nelson (right), with Pat Verlanic

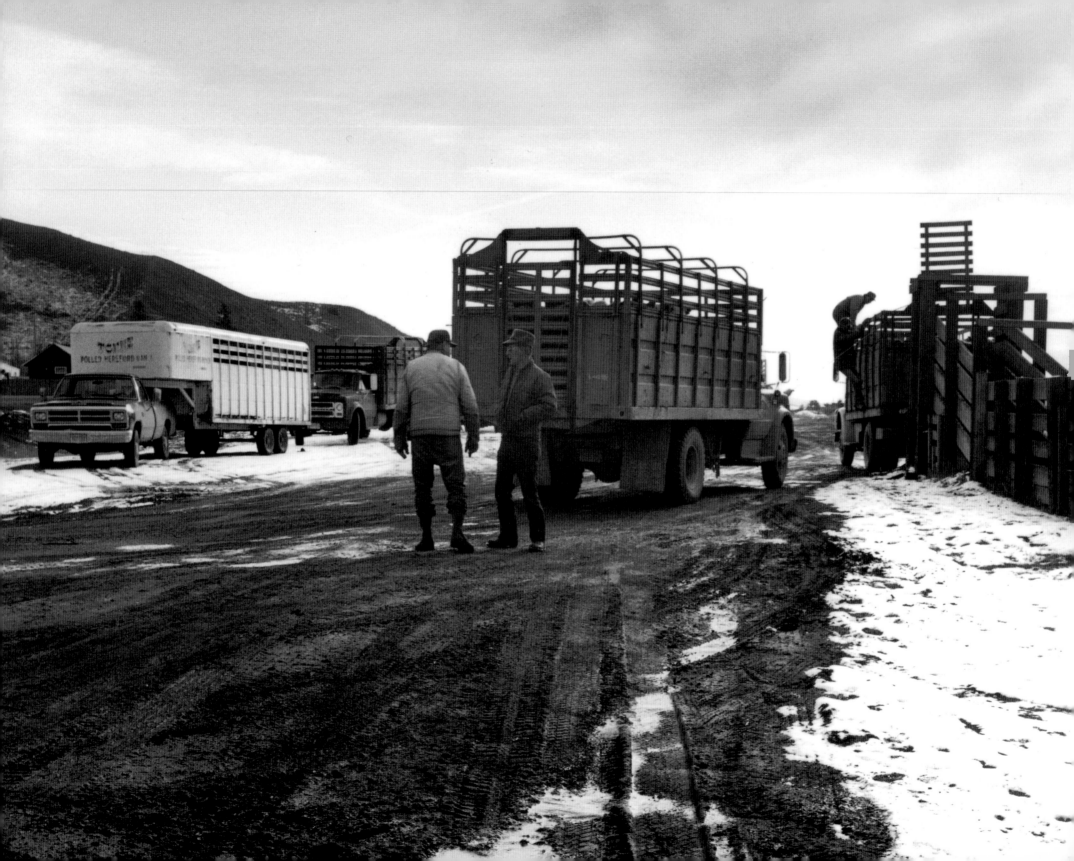

Facing page: Jack's cattle are unloaded at Mentzer's Stockyards.

Right: Joy rakes leaves in her mother's side yard with Justin and Shawn. Shawn, who is in the background and is sixteen years old in this photo, has now finished college and has come back to ranch full-time. Justin is thirteen years old here.

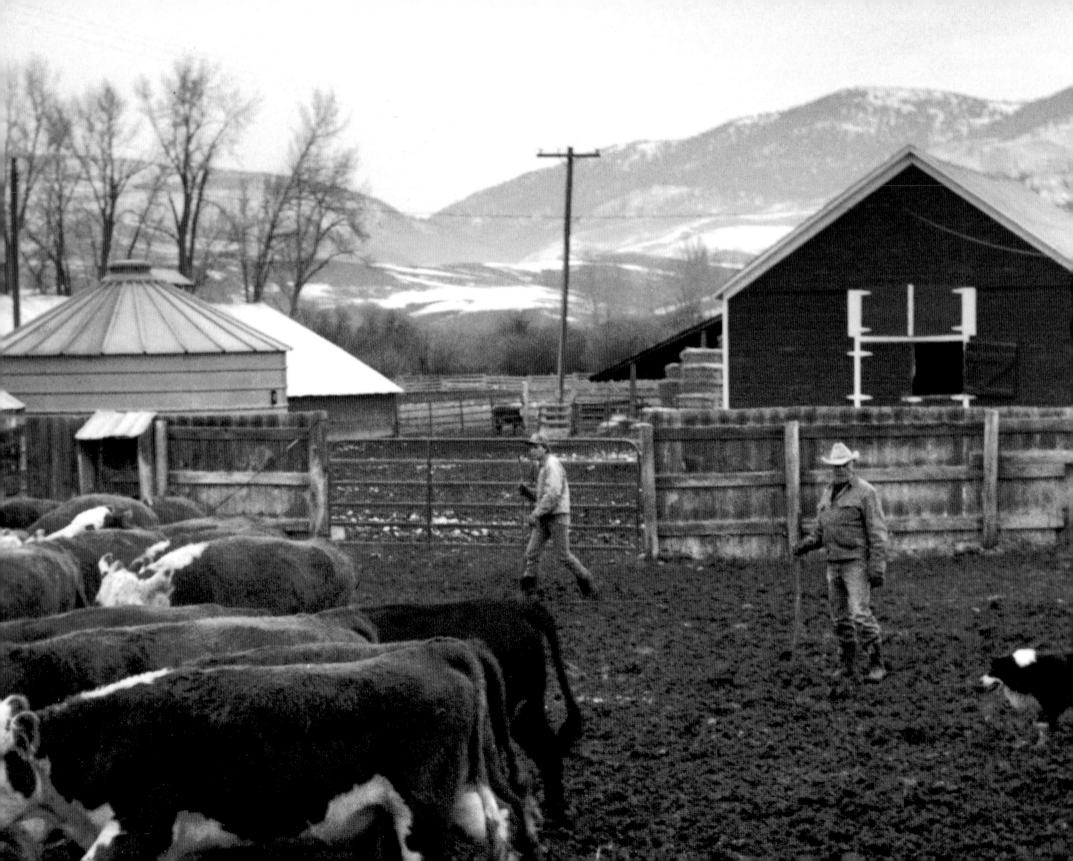

They kept calling Ron the Cattle Buyer in that new hat of his. He's a good man. If it hadn't been for him and Joy, we'd have had to get rid of our place. We couldn't have handled it by ourselves.

—JACK NELSON

Facing page: Scott Struna, Jack's great-nephew (left), and Jack sort cattle for market.

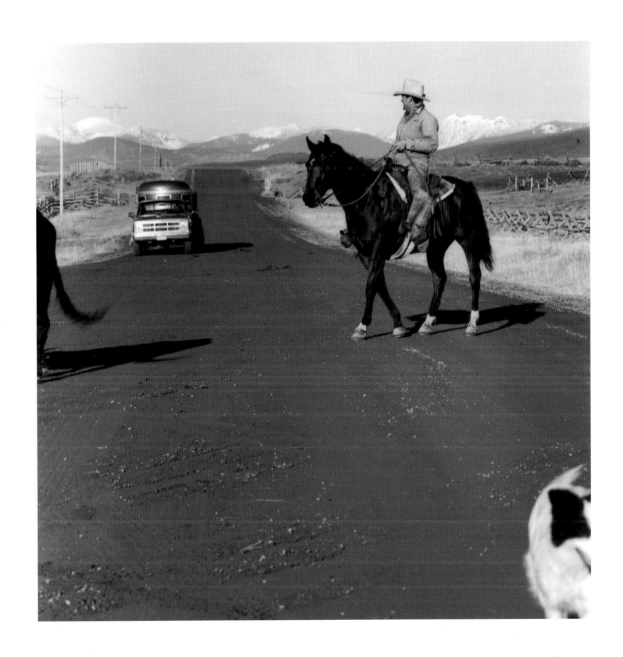

Joe Verlanic (left) and Ed Radtke, neighboring ranchers, wait to load Jack's calves.

W e preg-test our cows, even though it isn't 100 percent. The vet can tell if a cow is open, but if a cow is bred in less than forty-five days, sometimes they can't feel the calf yet. Today we tested 365 cows, so sometimes there's mistakes when you do that many. Our vet does pretty good, though, considering what he has to do—put his arm in up to his elbow, and feel around.

—JACK NELSON

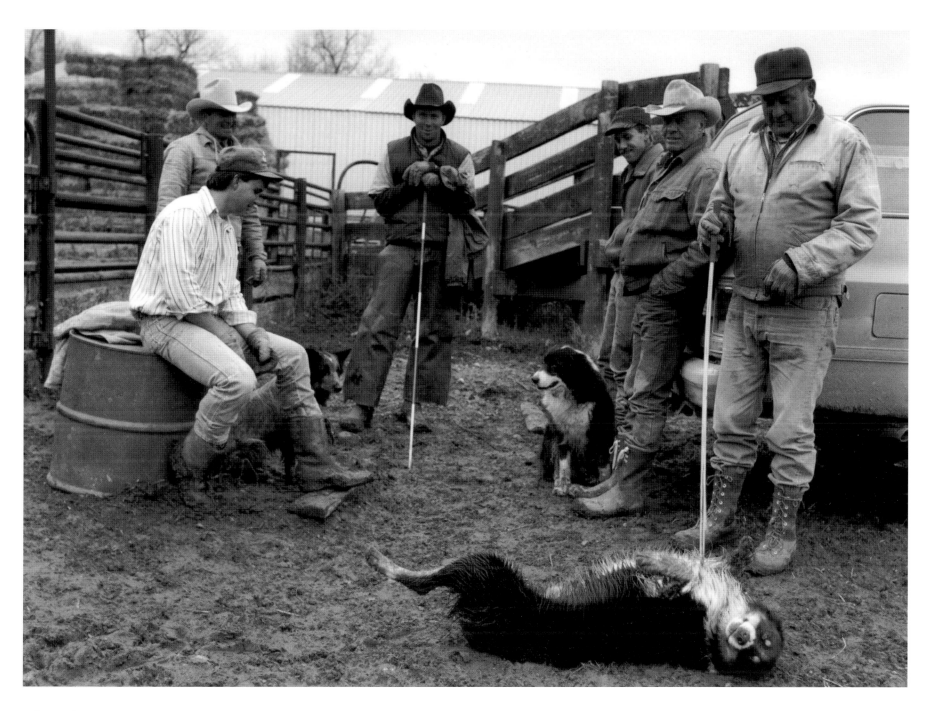

Left to right: Scott Struna, Ron Wetsch, Pat Verlanic, Dr. Tom Linfield, Jack Nelson, and Joe Verlanic

Jack "changing water"—opening floodgates—in one of his fields

O ne day my sister-in-law brought us this bag that she thought was just old scraps. She found it in the attic. At the bottom of the bag was most of this quilt, but it didn't have a border. So we had the quilt finished by Joann Farley using the scraps. All these pieces are from our dresses and things. The pieces with the bluebirds are my favorites—they were from my nightgown.

—ONITA NELSON

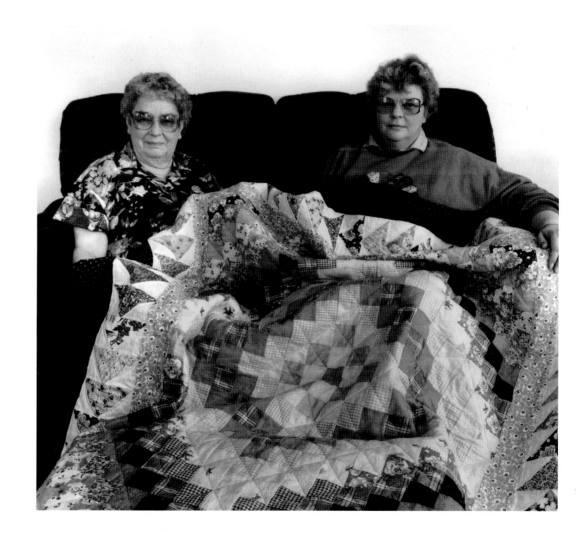

Facing page: In general Joy and her mother do not work in the fields or with the cattle, but they do keep the books and provide occasional ranch help if they are needed. Except for the years Joy was away at college, and two years at the beginning of her marriage, she and her mother have always lived within 20 yards of each other.

can tell you something that's different than when we first moved in to our house in 1943. I've got electricity now. I have a bathroom and water in the house, and I got a washing machine. Those were big days in my life when I got those. Our house was just a little tarpaper shack, 30 by 16, built during the war when you couldn't get all the things to build a house. I was bigger than that little house. Oh, lordy, it isn't even fun to think about. We moved in on the night of April 15th, and on the morning of the 16th I got up and cooked breakfast for the hired man. I didn't know how the stove worked, I didn't know how to cook, except to bake. I didn't know anything. It's hard to believe. We had three little rooms and a privy out back. We slept in a tent in the summertime because the house was too hot on account of the tarpaper. I usually tried to cook my big meal by noon and then kind of have leftovers for evening, so that the house wouldn't get too hot. I had a gas-motored washing machine, and the thing would die, and I couldn't get it started, and I'd have to leave the wash until it was going. Jack's always giving me a hard time because we had the hired man, and here I was, washing clothes by hand, and I always put a tablecloth on the table. And of course, I'd iron it. Those irons were terrible. This was all before we had electricity in the house, so I'd just heat the iron on the stove. The electricity came in 1946, a year after Gordon was born. We got the phone about a year after we got the electricity. Joy was a year old when we got the water, so that was in 1951. And the road from our gate to our house, which is about a mile long, it was just a disaster area until the kids started school and we finally had to fix it up. That was the way it was. We didn't think we were bad off. We were young and happy and didn't know any better. Now our house is real nice. It's been built onto seven times, can you imagine that? But it's warm in the winter and stays cool in the summer.

—ONITA NELSON

152

Left to right: Sheila Verlanic, Onita Nelson, and Joy Wetsch in Sheila's kitchen

I t can get very cold and blowy up in that cemetery.

But one time, in the summer, Jack and I went up

there, and Mary Jensen was up there, and the

three of us sat on the curb and talked. It was peaceful,

quiet. And it was so pretty looking out over the valley.

—ONITA NELSON

Afterword

When I first began photographing and interviewing in Drummond, I simply used my eyes and ears. The lives that these people seemed to be living were all of one piece, something I could not say of my own life, and they seemed at peace with themselves, something I could not say about most of the people I knew. Yes, they had complaints—about environmentalists, about the price of grain, about the price they are paid per animal, about vegetarians, about Bill and Hillary Clinton, about stupid things their neighbors or kids did. But they never complained about their lives, even though they had a very clear understanding of the difficulties they faced. As a matter of fact, they openly celebrated their good fortune at being able to live in such a glorious place, doing what they love to do. So it didn't take me long to realize that while most Americans have what we call a "lifestyle," these people have a life. And people like that seem fortunate, not tragic, to me.

But when I would come back East with my photos and my tapes, people kept accusing me of casting a blind eye on "reality." Obviously, if we could see the handwriting on the wall about the grim prospects for rural resource producers, they, who were in the thick of it, must be made to see, if they are not already consciously aware of it, how pessimistic their future is. So, finally, three years after I made my first visit to Drummond, I asked several ranchers what they thought the future of ranching would be. At first, the question seemed irrelevant to them. If you have to eat, you have to have people who produce the food, was their general response. Gradually, we were able to touch closer to the heart of the dilemma that most rural family farms and ranches will be facing.

People who work the land have always been threatened by economic and population pressures. The difference between the pressures today and those of the past is that the threats to survival seem less related to the normal boom and bust cycles that often result in abandoned and foreclosed lands, and more related to corporate buyouts combined with the general indifference Americans seem to feel about what used to be called The American Dream. "The whole idea of coming 'West' to seek your fortune," said rancher Pat Verlanic, "is changing. There's still an independence and a mystery thing about it. But the reality of it is that people don't want to have to put in the work, to go through all the drudgery for that independence."

In addition, mechanization and technology have completely changed the face of ranching, without bringing a commensurate rise in the standard

of living. "It's hard just to be able to afford to buy equipment," continued Pat. "Let's say you need a new tractor. In 1970 you got 70 cents per pound for your calves, gas was about 70 cents, and the tractor cost $3,000. Last year, we got 78 cents for the calves, gas has doubled, and a new tractor costs at least $30,000. You can still only run so many cows per acre. So you're still paying for the tractor and gas with the same amount of cows that you had twenty-five years ago."

Bill Ohrmann's greatest sadness came not in thinking about the change from manpower to machinery but in the community standards that changed with the shift. Nearly everyone I spoke to referred to the loss of the sense of community as being the thing that will deal the fatal blow to rural America. "This valley was very different when there were men that we'd pick up off the freight cars," Bill said. "We called them bums. But they were all decent people, and they'd come back here for years. I'm not saying we should go back to horses and hire bums, but it made for a different kind of community."

Sitting here, far from Montana, looking over all of the transcripts of all the discussions I have had with the people of Drummond over the years, two things come to mind. The first is that if I continue to ask ranchers about the future of ranching, I think their responses will still run along the lines that as long as there are people who love the land and are willing to put in the hard work, despite being underpaid and under-valued, there will always be food on our tables. The format of how they work and who underpays them may change, but they will retain their identity, doing what they do best by doing what they love to do.

The second is that maybe this isn't really a question at all. Maybe it is really a disguised command, telling ranchers how they should be thinking and doing things and how they should be living. And maybe that is not a good thing to do. So what if everyone doesn't keep their fingers on the pulse of change the way others expect them to do? So what if everyone does not look at the future in exactly the same way? So what if some folks are actually still living what appear to be mythical lives in the mythic West? Does that make what they're doing wrong or silly or undignified?

I am not saying that I am sorry that I asked the question. Nor do I think that the ranchers minded thinking about it with me. But by asking, I solidified something much more important, both about them and about assumptions in general. As I said at the beginning, I first came out to Drummond expecting to find a community wallowing in self-pity, only to

find that I was wrong. Thankfully, I didn't do it by pushing and poking and making the people of that town debunk my theory. I did it by listening, by being open, no matter what it was they had to say. Because by doing it that way, I learned to hear differently and to appreciate points of view that I had either never considered or had considered unimportant. It's a small point, but so critical: How much of an agenda we bring with us often determines not only what we hear but how much people are willing to tell us. Because I never looked down on them, they didn't look down on me when they knew they were being asked "poison pill" questions.

In the end, though, I am glad that in most of my conversations I did not ask them to define themselves by standards that were not their own, but to share stories and knowledge that were uniquely theirs. By being the latest in generations of people who have settled into one place and know it by heart, they had much to tell. And I am honored to have been able to record it, both in words and in pictures.

—JILL BRODY, PROVIDENCE, RHODE ISLAND, 2003